Heat Transfer
Techniques

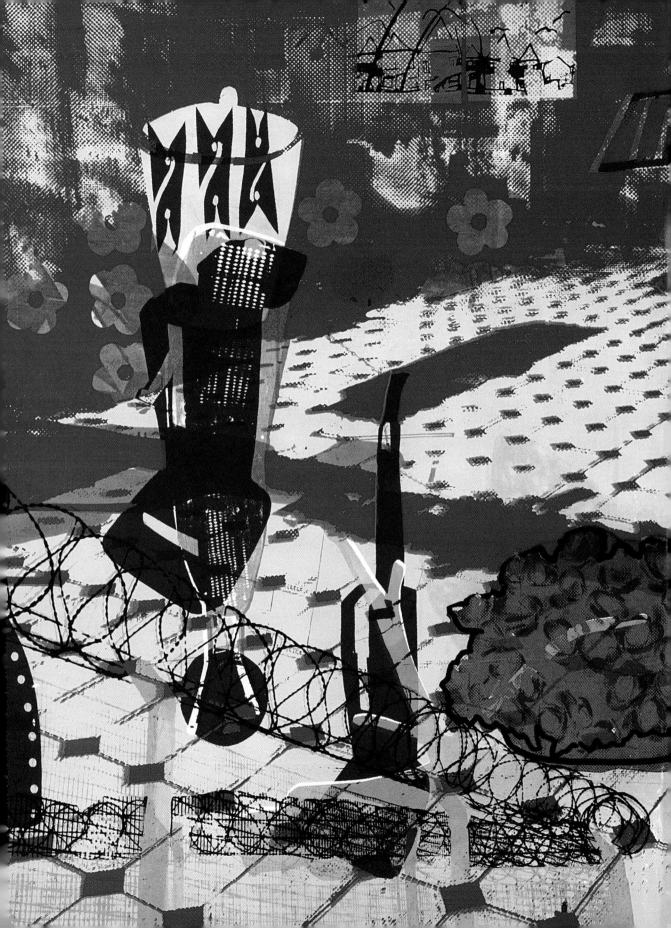

Heat Transfer Techniques

Dawn Dupree

A & C BLACK · LONDON

Acknowledgements

I would like to thank all the artists and designers who contributed images of their work, and Fiona King for her assistance.

First published in Great Britain 2011
A&C Black Publishers,
an imprint of Bloomsbury Publishing Plc
36 Soho Square
London W1D 3QY
www.acblack.com

ISBN: 9781408109113

Commissioning editor: Susan James
Managing editor: Davida Saunders
Cover and series design:
Sutchinda Rangsi Thompson
Page layout: Evelin Kasikov
Copyeditor: Julian Beecroft

Typeset in 10 on 13pt Bliss Light

Printed and bound by C&C Offset Printing Co., China

This book is produced using paper that is made from wood grown in managed, sustainable forests. It is natural, renewable and recyclable. The logging and manufacturing processes conform to the environmental regulations of the country of origin.

Information given in this book is to the author's best knowledge and every effort has been made to ensure accuracy and safety but neither the author nor publisher can be held responsible for any resulting injury, damage or loss to either persons or property. Any further information that will assist in updating of any future editions would be gratefully received.

IMAGES
Front cover: (*above left*) Morphic damask hand-printed wallpaper, Linda Florence, 2006, photo: Linda Florence (fig.13, p.36); (*above right*) Turbulence (detail), Dawn Dupree, 2009, photo: Dawn Dupree (fig.10, p.45); (*below right*) *Domestic Bliss* (detail), Dawn Dupree, 2008, photo: FXP Photography (fig.01, p.6); (*below left*) *Pink Silk*, Heather Belcher, 2005, photo: David Ramkalawon (fig.15, p.58).

Back cover: *Membranes 1* (samples), Zane Berzina, 2002, photo: Zane Berzina, (fig.08, p.93).

Frontispiece: *Domestic Bliss* (detail), Dawn Dupree, 2008, photo: FXP Photography (fig.01, p.6).

Opposite: (*left*) selection of open-screen foil prints on cotton, raw silk and felt, Dawn Dupree, photo: FXP Photography (fig.11, p.37); (*centre*) *Pins*, Rebecca Earley, 1994, photo: BE (fig.05, p.9); (*right*) *Membranes 1* (samples), Zane Berzina, 2002, photo: Zane Berzina (fig.01, p.106).

Contents

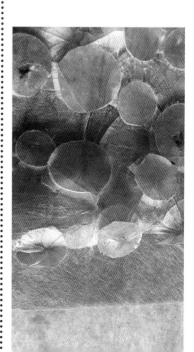

Introduction

1

Heat Transfer Techniques explores how to experiment with a variety of processes using a heat press or domestic iron. This comprehensive and practical guide explains exciting new methods with relatively low impact to the environment, often utilising recycled materials and ways to upcycle. Designed to be accessible to artists, designers, students, teachers and novices, this handbook will cater to all levels of ability, and a broad range of contexts.

Each chapter explains a specific process in depth, with instructions for simple experiments and suggestions for further investigation. Helpful hints (as well as pitfalls to avoid) are also featured, from basic techniques that can be used in a classroom, to more complex methods aimed at artists and designers. Subjects include flock printing, foiling, phototransfer, dye sublimation, fusing, heat-setting and embossing. Advice is given on materials, equipment, and health and safety. Studio samples, along with ideas for experimenting and projects, support and give further insight into each technique. Illustrated examples of work by contemporary practitioners, designers and students reflect the diverse application of heat-transfer techniques, incorporating fashion, fine art, interiors and installation.

A culmination of research including studio experiments and documentation, *Heat Transfer Techniques* captures a spirit of investigation, scientific recording and creative adventure at the cutting edge of contemporary textile practice.

As an artist working primarily with textile practices, I am constantly exploring new ways to experiment with methods, processes and materials. I have always enjoyed interacting with print processes, to manipulate, distort and saturate the surfaces of textiles.

03

01 *Domestic Bliss*, Dawn Dupree, 2008. *Screenprinted wall panel with flock printing, 105 x 76 x 6 cm (41 x 30 x 2½ in.). Photo: FXP Photography*

02 *Separation*, Dawn Dupree, 2010. *Digital sublimation printing on Ripstop™ nylon, approx. 61 x 91.5 cm (2 x 3 ft.). Photo: Dawn Dupree*

03 *Shadow*, Dawn Dupree, 2010. *Lightbox and printing on Ripstop™ nylon, approx. 45.8 x 45.8 cm (1½ x 1½ in.). Photo: Dawn Dupree.*

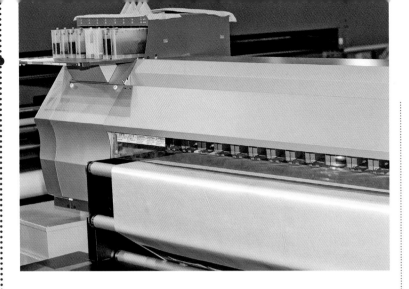

Over recent years my work has incorporated a number of heat-press techniques including flock printing and foiling (culminating in multi-layered surfaces). I have also experimented with digital transfer prints (see chapter 9) and translucent fibres to produce installation pieces and mixed-media light boxes. I have written this book because, after several years of studio practice and teaching experience, I wanted to share my discoveries and inspire others to experiment with heat-transfer techniques and explore their limitless possibilities.

A brief history

Transfer printing (otherwise known as sublistatic printing) was invented in France in the 1950s and first developed in Switzerland in 1957. This method of dry-heat transfer, or sublimation printing, transformed the way many promotional products, and in particular sportswear, were produced and decorated.

During the 1970s, screen-printing was the main method of printing onto a range of products, including T-shirts, caps, tea towels and drink-holders. Gradually, things have changed, though not all at once: plastic transfers printed onto transfer material, for instance, replaced printing directly onto caps, before digital embroidery took over during the 1990s, but most T-shirts were still being screenprinted until new sublimation technology came along. It has to be said that sublimation transfers were already being produced by offset printing, but these were limited to transfer onto polyester alone, which made for garments that were uncomfortable to wear.

After the year 2000, sublimation inks were developed for inkjet printers, which by happy coincidence was matched by the development of 'cool dry' or breathable sports material. This was also made of 100%

polyester, but with the new advantage of allowing moisture to transfer out of the material, thus creating a far superior, more comfortable sportswear fabric that could be transfer-printed in this way. This method of sublimation printing could also be used for printing onto neoprene (drink-holder) material, so it is hardly surprising that it quickly took hold in the marketplace. The main advantages of using inkjet printers for this process were the ability to produce an unlimited range of colours and full photographic prints without any films or screens. Added to this was a cleaner method that was far cheaper to set up. As a result, it became possible to use sublimation printing at home on a small scale with a heat press and an inkjet printer using special sublimation inks.

Inkjet printers and laser printers are also commonly used to produce transfers (phototransfer) that are printed using their original inks. There have been enormous improvements with these transfer materials, especially in terms of durability. The advantage of this method is that the transfers can be used on all fabrics and are not limited to man-made fibres (as with sublimation printing). The disadvantage is the slightly plastic finish some of these transfers can leave on the surface of the garment or fabric once heat-pressed, as opposed to dye sublimation, which involves fusing inks deeply into the fibres of the fabric.

Screenprinting became extremely marginalized with the arrival of direct garment printing. The potential to print directly onto clothing made of almost any fabric (and then heat-press to fix) was enormous.

Heat-transfer printing technology has a wide range of commercial applications and serves a rapidly growing industry. Dye sublimation provides a cost-effective way to produce banners, posters and exhibition signage (on any scale), and is often used for businesses as a promotional tool. Indeed, sportswear production utilising dye sublimation as a process to print logos and designs onto synthetic fibres is thriving.

The internet features many companies supplying an extensive range of products suitable for heat-press technology. Cups, mugs, tea towels, mouse mats, coasters, etc. are available to embellish with heat-pressed designs as affordable products for the gift market.

For a number of years, the fashion industry has been incorporating heat-transfer techniques to print sublimation designs onto fabrics, while flock and foil transfers are widely used to embellish garments. Interior design products now often feature a range of heat-press techniques.

05 *Pins*, Rebecca Earley, 1994. *Pins, paper, transfer inks, polyester satin. Heat photogram, 50 x 70 cm (19¾ x 27½ in.). Photo: BE.*

06 *Weathering the Storm*, Dawn Dupree, 2009. *Screenprinted wall panels with flock printing, left panel approx. 76 x 50.8 cm (30 x 20 in.); right panel approx. 76 x 76 cm (30 x 30 in.). Photo: FXP Photography.*

Away from the commercial world, over the past 20 years, as processes have filtered through and ideas have developed, a growing number of artists and designers have employed heat-transfer methods in a variety of interesting and innovative ways. These include textile artist Rebecca Earley (see p.60). Rebecca coined the phrase 'heat photogram' with her fabric designs featuring feathers and pins, produced using the dye-sublimation process. She has since continued to develop her work and research into ideas around upcycling at Textile Environment Design (TED).

Nowadays heat-press techniques have become an integral and pertinent way of working for many designers and artists, as you will see in the range of exciting products, samples and artworks illustrated in this book. Creative businesses have also embraced heat press techniques. For example, Conserve is a company set up in India that recycles plastic bags collected by rag pickers into 'fashbags' – coloured plastic is fused together to form sheets that are then manufactured into handbags.

Since I began teaching during the 1990s, heat presses have become an integral part of print-workshop facilities. Universities have embraced heat-transfer technology, and basic techniques are often incorporated into many textile-design, fashion and surface-pattern courses. With affordable machinery available on a small and portable scale, and materials sold in small quantities, heat-press processes have also become far more accessible to all. This is the first book to outline specific processes, focusing mainly on experimentation, and to discuss the creative potential of heat-press technology.

Health and Safety

2

Heat presses

The main hazard when working with a heat press is the risk of burns. It is therefore advisable to take a few precautions when experimenting with heat-transfer techniques.

Heat presses should be placed on a secure and stable surface, away from the edge. If you're using a swing-away press, allow enough space to accommodate the movement of the press. Keep the immediate area around your heat press uncluttered to minimize any potential fire hazard.

Heat presses are generally used at temperatures of 140–200°C (284–392°F), so make sure you do not touch the metal plate at any time the press is in use. This is particularly important if you are running a workshop with children, young people or individuals from vulnerable sectors of the community. To prevent any risk of burns, do not leave your heat press unattended, and take care to secure any extension leads or cables to avoid tripping over them. Always check there is a sink nearby, and locate the first-aid box, before you begin using any heat press.

If working in a noisy environment, do not leave your heat press unattended, as you may not hear the time alarm.

To protect your heat-press plate, make sure you always cover your work with a Teflon™ sheet (baking or other paper can be used as alternatives with some techniques). Similarly, to protect the base of the heat press, you should place Teflon™ (or baking paper or similar) underneath your work.

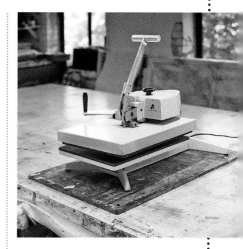

01 *A heat press in a print studio. Photo: FXP Photography.*

If you accidentally melt or stick something onto the metal plate, your heat press must be unplugged immediately. You should then wait it is until completely cool before attempting to remove any materials fused to the surface of the plate. Once these have been removed, you may wish to heat-press on a medium setting (for a few minutes) directly onto a piece of cotton, to remove any residual plastic or glue marks.

Do not attempt to place large objects that could potentially damage the metal plate into your heat press. Take care when using metal shapes for embossing, and loosen the pressure wheel if necessary.

Also, if you are fusing several layers together, or heat-pressing thicker fabrics, adjust the height of the metal plate to enable you to close the press without using excessive force.

When experimenting with different times and temperatures during the heat-press process, it is advisable to take extra care when using plastic and other shrinkable materials (packaging/webs, etc.). Sometimes steam will escape from the sides of the press, and there may be a hissing noise as materials are fused or melted. If you're unsure, release the plate before the timer is finished. You can always press again, or for longer, if required.

To avoid any risk of burns, always allow fabrics and materials to cool after heat-pressing before removing them from the heat press. This is particularly important when working with materials that melt during fusing processes, or metal objects used with embossing, as these tend to retain heat for a considerable time once heat-pressed.

Irons

To protect your iron always place your materials between two sheets of baking paper (for some processes you can use fabric or tissue paper). To avoid any risk of fire, do not leave your iron unattended when hot. Take care not to burn yourself, and wait for materials to cool completely after pressing them with an iron.

Screen emulsion

Gloves and eye/face protection must be used when mixing some photo-emulsions for coating silkscreens. Please read the manufacturer's instructions before using.

02 *Liquid transfer paints come in a range of colours. They are painted onto paper first and then tranferred to the fabric using a heat press. Photo: Dawn Dupree.*

03 *Angelina fibres. Photo: Dawn Dupree.*

04 *Craft knives, scissors and pins on a cutting mat. Photo: Dawn Dupree.*

Glues

Flock and foil adhesives are mainly water-based and safe to use without protection. However, some companies also sell solvent-based products, so it's advisable to read any technical and safety data sheets prior to use.

Dyes

When preparing powdered disperse dyes (for sublimation printing) use protective eyewear, surgical or Marigold gloves, and a dust mask (available from any hardware shop) to avoid inhaling any dust particles. Once in liquid form, your mask can be removed, but care must be taken not to stain skin or clothing. Always wear an apron and gloves to avoid any contact. Dyes can be kept in airtight containers to use at a later date, but must be stored out of reach of children and pets and away from foodstuffs. Comprehensive safety notes are available from the companies that sell the dyes. Make sure you clear up any spillages, to avoid the risk of slipping over.

Transfer inks

Wear gloves and protective clothing, as transfer inks are similar to dyes and will stain.

Angelina fibres

These fibres are completely non-toxic. Take care when using them, making sure they are completely cool before removing them from the baking paper.

Scissors, craft knives, needles and pins

Take care when using sharp objects, particularly in a workshop setting.

Most products and materials used in heat-transfer processes are safe and have a low impact on the environment. Recycled materials can be used in several processes.

> **NOTE**
> All companies supplying products with hazardous ingredients generally have specific information about them on their websites, and include instructions for health and safety.

03

04

Equipment and Materials

3

Simple heat-transfer techniques can be carried out with very little equipment. A domestic iron and a kitchen table covered with fabric will accommodate a basic range of experiments or samples.

This chapter outlines some of the equipment needed, and various methods you can use, in experimenting with heat-transfer methods. Also covered are general machinery and materials used for setting up and working with heat-press processes.

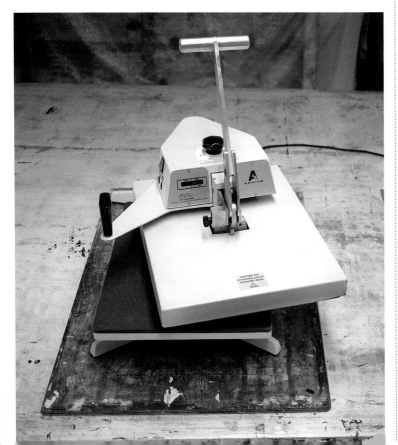

01 *A swing-away heat press. Photo: FXP Photography.*

The subsequent technique chapters include details of the specific materials needed for each particular process. There is also a chapter covering design development and the associated materials, and screen preparation, including relevant equipment.

In this chapter I also discuss factors you may wish to think about when looking at and buying equipment for use with the techniques and settings explored in this book.

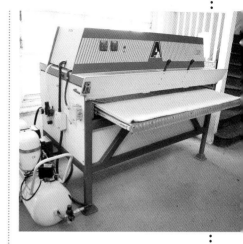

02 *Large-scale draw-style heat press. Photo: Dawn Dupree.*

Heat presses (otherwise known as transfer presses or sublimation presses)

When deciding which heat press to buy (or hire), bear in mind that they vary enormously in size, style, type, weight, quality and price. It is worth researching a number of companies to find a press to suit your individual needs and situation. Below I have outlined some of the different types of heat press available, describing their main features.

Small, lightweight presses

Lightweight heat presses are reasonably priced and are useful in a domestic setting or if a portable press is needed. This can be extremely helpful when running a workshop or working in a small space.

Flat-bed heat press

Flat-bed heat presses are used for heat-transfer processes onto flat surfaces, e.g. fabric. There are three types available: clamshell, swing-away and draw-style.

Clamshell heat press

This press is quick and easy to operate. It has the advantage of being compact, needing only a small work area. However, you will be operating underneath a hot surface, so it is not suitable for processes where laying out materials takes some time. Another disadvantage is that some clam presses can pinch the work at the back of the press, giving an uneven pressure, and hence possibly a distorted design.

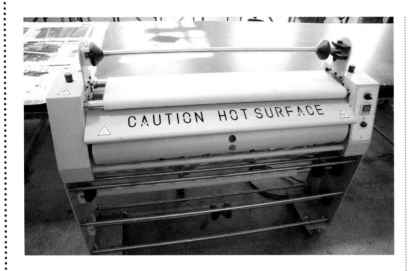

03 *Roller heat press.*
Photo: Dawn Dupree.

Swing-away heat press

Additional space is needed to accommodate this type of press, but it has the advantage of leaving you with a completely heat-free workspace.

Draw-style heat press

As with the swing-away, this press is simple to operate. By sliding a drawer out from the press, work can be assembled away from the hotplate without requiring extra space.

Roller heat press

The roller heat press is especially useful if you want to heat-transfer onto a length of fabric or a longer piece of work. The advantage of using this kind of press is that you can transfer seamless designs, printing larger areas of fabric without any breaks or overlaps in colour. However, there is a width restriction depending on the size of press you use. The fabric and sublimation paper are fed between two felt-covered and heated rollers (similar to a mangle). The pressure and temperature transfer the design from the paper to the fabric.

If you cannot afford to purchase a heat press, or you wish to make work larger than your heat press can accommodate, you may decide to use the services of a local college or print facility. Details of some

of the places that hire equipment in this way are listed in the courses and facilities chapter at the end of this book, but it is a good idea to contact any schools, colleges, print workshops or universities in your area to check whether this option is available.

Dye-sublimation printers and inkjet printers using sublimation ink

A dye-sublimation printer is a computer printer that incorporates the use of heat during the printing process, to transfer dye onto various surfaces including paper and fabric. The original printers employed an electrostatic technology using toners, but now, modern, large-format inkjet printers that use specially formulated inks are available.

There are two main types of sublimation printing carried out using a sublimation printer or an inkjet printer. The first method involves printing onto a transfer paper or carrier sheet, which is then transferred onto fabric or another suitable surface using a heat press. The other method is printing sublimation images directly onto fabric.

Dye sublimation printers come in various sizes and qualities to suit both small-scale work and large-scale production; desktop printers are suitable for a smaller domestic studio or education facility. Sublimation printers are widely available from various internet companies, and can be bought to print designs onto A4 or A3 paper using sublimation ink cartridges. These can be subsequently heat-transferred onto various synthetic and polymer surfaces.

Alternatively, selected inkjet printers that use Piezo™-printhead technology can accommodate the sublimation transfer process. In the past, this method was restricted to specific Epson™ inkjet printers, but can now be used with some Ricoh printers using Sublijet R cartridges. It is advisable to research these thoroughly before buying a sublimation printer or inkjet printer. Factors to bear in mind before investing in any of these options include the cost of different ink cartridges and variations in quality, as they can vary widely from one company to another.

You may also wish to look at whether you prefer to use other sublimation methods or services. When working on a larger scale or needing an enhanced quality, you could send or take your designs (saved in reverse onto memory stick or CD in tiff format) to a company

supplying a digital print service (see the suppliers' list). They will print your designs with a digital printer using disperse dyes onto specially coated paper. You can then heat-press your designs onto synthetic fabric or a polyester/polymer-coated surface, using either your own heat press or hiring a larger-scale one if necessary.

Work area

The type of space you need will depend mainly on the scale of the work you wish to produce. I have successfully carried out heat-press workshops in small community or classroom settings with very limited equipment. However, a sturdy table and access to a sink are necessary for most of the techniques described in this book, which use either a heat press or an iron. Larger-scale or more ambitious work will need to be carried out in a studio or textile workshop with access to a heat press and screenprinting equipment if needed.

Irons and hairdryers

Any type of iron can be used for some heat-press techniques. Foiling is one of the most successful methods when using an iron, and small areas of flocking and fusing can be easily achieved in this way. Dye-sublimation processes can also be carried out using an iron, but for darker or more intense colours you will need to use a heat press.

Always make sure you protect your iron sufficiently, by covering your work with paper or fabric (depending on the technique being used). It may be necessary to replace your protective paper or fabric regularly to avoid burning or back-staining caused by the dye sublimation process. Clean your iron thoroughly if it becomes stained with dye, and if any materials become stuck to the surface, let it cool completely before attempting to remove them.

Protective coverings

Teflon™ sheets come in various sizes and qualities. Make sure you buy a sheet large enough to cover your work and/or heat-press bed. They are very durable and can be used for a long time, but they can also

occasionally become impregnated with dye. If this happens, wipe clean with warm water to remove it. Eventually your Teflon™ sheet may deteriorate and need to be replaced.

As an alternative to a Teflon™ sheet, baking or greaseproof paper can be bought from most supermarkets and is very useful for all heat-press techniques. I also use large sheets of newsprint paper for most dye-sublimation experiments conducted in a heat press, as it absorbs dye effectively and can be easily replaced to prevent any back-staining on subsequent samples.

Tissue paper is useful when fusing angelina fibres together for a few seconds, while felt or a similar material (a woollen blanket would do) is great for cushioning your heat press when using metal objects during embossing processes.

Canvas, cotton or calico come in various weights, and are perfect for covering your heat-press base or for sandwiching your work between when using an iron. You may need to vary the thickness of the fabric used, to allow enough heat to penetrate while still ensuring your technique is effective.

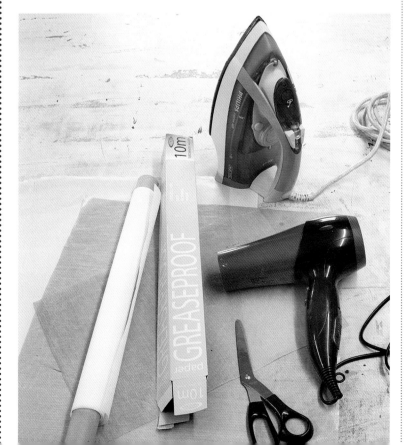

04 *Basic materials for heat-press techniques. Photo: FXP Photography.*

Design Development

4

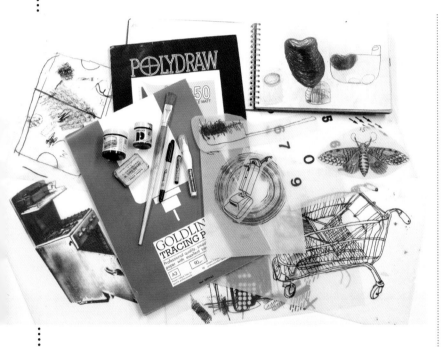

In this chapter I will give an overview of some of the methods you can use to generate designs, before these are transferred onto silkscreen. They can then be used together with a number of heat-press techniques, e.g. to print a flock or foil design.

There are several books available that focus on developing designs and artwork; these describe in detail how to harness or record initial inspiration, as well as how to utilize different methods and techniques during the design process (see Further Reading at the end of this book).

In keeping with the style of the rest of the book, I will approach the development of design work from a practical perspective, covering different methods to consider when producing designs to be transferred onto silkscreen or 'screen-ready' artwork. This involves creating a 'positive', i.e. any opaque image or design on any translucent surface.

Source material

Firstly, you need to consider your source material, and how this may be translated into a design that could be used for silkscreen printing. There are limitless ways to generate initial designs, including sketchbook drawings, photographs, collages, book illustrations, scanned images, Letraset and computer-generated designs. This source material can be further manipulated – cut and pasted, enlarged, overlaid, repeated and reproduced – to create a design you may wish to transfer to silkscreen.

The quality of your original image will contribute to the outcome of your final design. You can use this to your advantage: for example, hand-painted brushstrokes or poor resolution can often produce interesting results as marks or imagery break down during enlarging, copying or transferring processes. Various methods of image manipulation (e.g. Photoshop) can add further distortion, and experimenting with a range of possibilities at this stage can lead to some unique designs.

There are two essential outcomes: first to produce an opaque or semi-opaque design; and second, to produce the design on a transparent surface, e.g. black lines on tracing paper.

02 *Examples of a range of source materials used to develop design ideas. Photo: Dawn Dupree.*

Translucent materials

If you have generated or developed your design using one or more of the methods described above, you will need to photocopy or print it onto tracing paper or acetate. You must make sure that your final design is suitable for transferring onto silkscreen, as the photographic exposure method will translate it in a fairly crude, black-and-white way. Therefore, the most successful silkscreen designs use high-contrast positives made from your original designs, photographs or drawings, where the black elements are opaque (i.e. light cannot pass through them).

However, while it is preferable for your tracing or acetate design to be highly contrasting and opaque, exciting results can be achieved when using a broader range of tones and opacities in your transparent designs, and these can often create grainy or unpredictable results.

Another factor to think about is the various types and qualities of photocopier available, which can also affect the outcome of your design. For example, when using a more sophisticated digital photocopier or a large-scale plan copier, you can choose between using a line or a photo setting, which will translate your design, respectively, either more crudely or with more detail. Some photocopiers feature an adjustable opacity setting as well as the darkness/lightness setting.

Acetate, onto which you can print your design using an inkjet printer, is available in various thicknesses and qualities. But make sure you allow your printed design to dry before handling, as some inks are unstable on acetate, and can easily be erased or blur. Folex™ is another transparent material that can be used to make a 'positive'. This can be printed onto using a laser printer. Alternatively, you can use other translucent materials to generate designs in a more direct and handmade way, which can then be transferred onto silkscreen by photographic exposure. These include Polydraw, a polyester drafting film which can be drawn onto using pencil or ink without distortion; and also Seritrace, a smooth-surfaced translucent product or similar (sometimes available with a textured surface), onto which you can paint or draw designs with various opaque, or semi-opaque drawing or painting materials, as described below.

You can also draw or paint directly onto tracing paper and acetate, but the results may be less successful.

Opaque materials

A broad range of opaque and semi-opaque materials and products can be used in conjunction with various translucent surfaces (Polydraw, Seritrace, tracing, acetate, etc.) to produce a positive design or screen-ready artwork, i.e. a design that can be photographically exposed onto a silkscreen in preparation for printing. Below I have suggested a number of products and described how they can be manipulated to create a range of qualities which can affect the outcome of your design in various ways.

Photographic opaque

Photographic opaque, available from design or graphic suppliers, is used to block out backgrounds on negatives, but is also a very useful product for painting directly onto Polydraw or Seritrace or another similar translucent surface. It is a thick paste that can be watered down to your desired consistency. When you have dried your painted marks, it can be scratched into, or partially washed off, to achieve various effects. Once you have transferred your design onto a silkscreen, photographic opaque can be completely washed off your transparent surface with water and reused.

Process black

Process black is an opaque watercolour that can be used on acetate as well as other translucent surfaces with a brush, pen or airbrush. This product is available from specialist art suppliers (see pp.118–21).

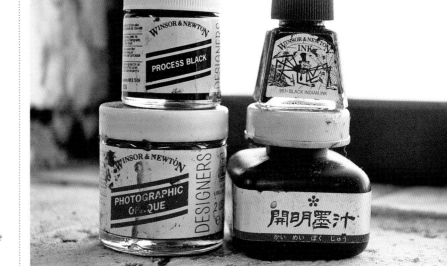

03 *Process black, photographic opaque and Indian and Japanese inks. Photo: Dawn Dupree.*

Oil pastel/lithographic crayon

Textured or grainy marks can be created on all translucent materials using oil pastels (dark colours work best) or lithographic crayons, usually sold in art and design shops.

Opaque pens/marker pens

Opaque pens and a selection of marker pens are generally stocked in most office or stationery suppliers. They can be applied to most translucent surfaces and allow greater control for drawing and illustration than the other products suggested, but sometimes produce a fragmented line when transferred to silkscreen as some pens are not fully opaque. This can, however, create interesting results, or else can be overcome by retracing your design to reinforce the original line.

Acrylic paint

Acrylic paint can be used to paint onto various transparent surfaces, creating a range of opaque and semi-opaque results dictated by how much water is added to the paint. The results you get from using this method can also be scratched into once dry, or washed off.

Inks

Black ink (Indian, Japanese or other) found in art shops, is suitable for producing a range of opaque marks when applied with either pen or brush to tracing paper and Polydraw.

> ▶ **NOTE**
> Tracing paper tends to cockle when certain liquid products are used, which leads to an uneven surface that may distort your design. It is therefore advisable to use liquids on the more sturdy translucent surfaces, e.g. Polydraw, Seritrace or similar. Experiment with different combinations of opaque materials and translucent surfaces for various effects.

Silkscreen Preparation

5

In this chapter I will give an overview of the equipment needed to prepare and produce a silkscreen that can be subsequently used with some of the heat-press techniques in this book. I will outline different methods that can be utilized to create a design on silkscreen using a variety of materials and to suit different budgets, settings and materials.

Further information about setting up a print workshop, including print table, washout bay and other specific areas is addressed in more detail in various textile print publications (see Further Reading at the end of this book).

There are a few options when it comes to either making or buying a silkscreen, the simplest and cheapest of which is to construct your own. Any wooden frame can be used as a base. Plain curtain netting or another textile mesh (bought from a textile print supplier) can be stretched around your frame and stapled onto the back. Make sure that the tension is even by systematically stapling half of each side at a time, then going back and stapling the other half of each side, pulling the mesh taut as you go.

01

02

01 *A rack of silkscreens. Photo: Dawn Dupree.*

02 *Squeegees come in different sizes. Photo: Dawn Dupree.*

A second option is to use professionally stretched wooden and metal textile frames. These can be bought from various textile print suppliers (see the list of suppliers at the end of the book). While initially this is a more expensive option, the mesh is of superior quality and these screens tend to be more durable.

Alternatively, if you do not wish to make or buy a screen to transfer your design using one of the methods described below, you can send your black and white image or design to a company where it can be made into a Thermofax (see the suppliers' list or look on the internet). This is effectively a very lightweight frame onto which your image is transferred. Thermofaxes are portable and can be sent through the post. They are especially useful where your facilities are limited as they are made in a range of smaller sizes. Small, lightweight squeegees can also be bought to print your design, and can be washed in a small sink and reused.

Transferring your design

Once you have prepared your silkscreen, there are a number of ways to create or transfer your design prior to printing, as in the following four approaches:

Paper stencil

Hand-cut paper stencils are a simple way to make a design to print with a silkscreen. Newsprint paper works well, as does any other paper that is not so thick that it causes bleeding under the edges. Simple or more complex designs can be cut out using a craft knife on a cutting mat.

▶ **NOTE**
Newly stretched screens, whether handmade or bought, need to be washed with washing-up liquid or degreaser prior to use. Be careful not to leave your screen near any sharp objects or surfaces, to avoid piercing the mesh.

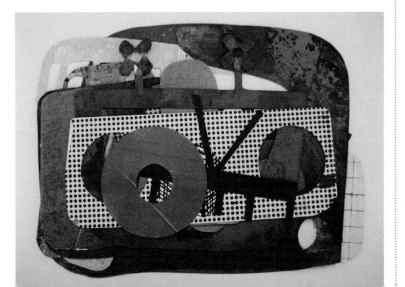

03 *Selection of paper stencils used for silkscreen printing. Photo: Dawn Dupree.*

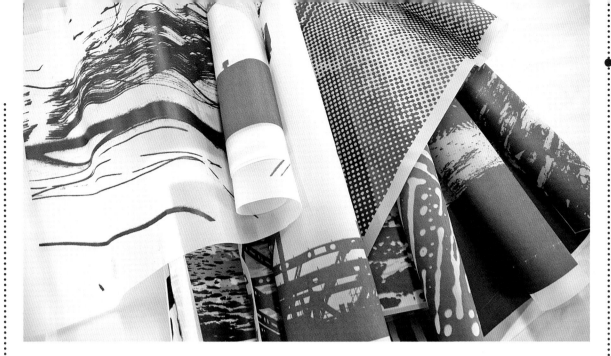

04 *Selection of photographic stencils on tracing paper. Photo: Dawn Dupree.*

Place either the negative or the positive part of your design onto your fabric, laying your silkscreen on top; it is not necessary to tape your stencil to your screen or your fabric. Print flock or foil adhesive through your screen and lift immediately. Your stencil will have stuck to your screen and can be removed, and you must wash your screen straightaway to prevent it from blocking. Dry your print and heat-press with flock or foil.

Paper stencils are temporary, but provide a quick and easy design solution.

Hand-cut film (stencil method) and screen-stencil film (self-adhesive)

There are several types of hand-cut film available, including Profilm (shellac) and Ulano™ (NuFilm/Blue Poly-2 Film). When using a hand-cut stencil (e.g. Profilm), the image or design areas are cut and removed from a lacquer film sheet attached to a paper backing. The remaining stencil is bonded to the screen mesh by using a liquid adhesive. The paper backing is removed once the adhesive is dry.

As an alternative to hand-cut film, you can use a self-adhesive screen-stencil film (e.g. Ulano™ NuFilm/Blue Poly-2 Film).

All films come with instructions for application and removal, and are available from various screenprinting suppliers (see the suppliers' list at the end of the book).

05 *Silkscreen with hand-painted images. Photo: Dawn Dupree.*

Hand-painted screen filler (negative and positive methods)

Speedball™ produce the most commonly used hand-painted screen filler system, available from a range of suppliers. There are two parts: drawing fluid and screen filler. The drawing fluid can be applied directly onto the outside of your screen to block areas you do not wish to print; this can be used independently to create a negative design. Alternatively, once the drawing fluid is dry, you can coat the whole surface of your screen with screen filler and wait for this to dry. Next comes a process of washing out, during which your original drawing-fluid design is washed away, leaving a positive design for you to print. Screen filler can be removed from your mesh with a combination of detergent, hot water and scrubbing.

Comprehensive instructions are given with all Speedball™ products.

Photographic stencil (exposure method)

This is the most durable method for transferring your designs onto silkscreen, but it also involves having access to an exposure unit (see the facilities section at the end of the book). The process involves coating the front of your silkscreen (using a coating trough) with light-sensitive photographic emulsion (see the suppliers' list for products). Your screen is then left to dry in a dark place.

Any type of positive transparency you have created can then be placed on a UV light box or exposure unit with your screen placed on top to transfer your design (there is no need to reverse your image during this process). Exposure times vary according to the equipment used, but two to three minutes is normal in most facilities. The more basic or homemade the equipment used, the longer it takes.

Photographic stencils can be removed with a high-pressure hose, after being coated with screen dissolve. But bear in mind that once screen dissolve has been applied to your screen, you must remove it within a few minutes: if you allow it to dry on your screen, your design will become impossible to remove.

Gloves should be worn when handling photographic emulsion, and gloves, safety goggles, a mask and protective clothing are needed when working with screen dissolve.

Photographic emulsion and screen dissolve are available from several screenprinting suppliers. However, these materials can be costly and once mixed last only a few months. It may therefore be best to use a print workshop facility or college that allows you to coat and expose your screen, so you pay for the emulsion and time you use (see the facilities section at the end of the book).

▶ NOTE

Always tape up your silkscreen once you have transferred your design, and prior to printing. Gummed tape, parcel tape or masking tape can all be used to frame your design on the outside of your screen (and to cover any holes). This will prevent any bleeding on the edges of your screen when printing.

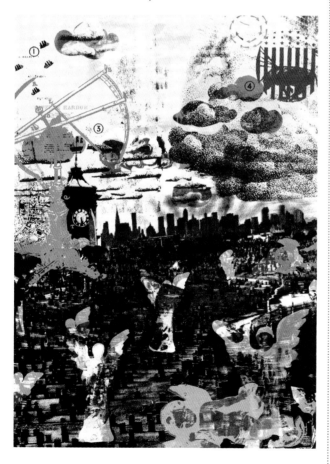

06 *Bubbles*, Dawn Dupree, 2007.
Screenprinted wall panel, 96.5 x 76 x 6 cm (38 x 30 x 2½ in.). Photo: Photographer.

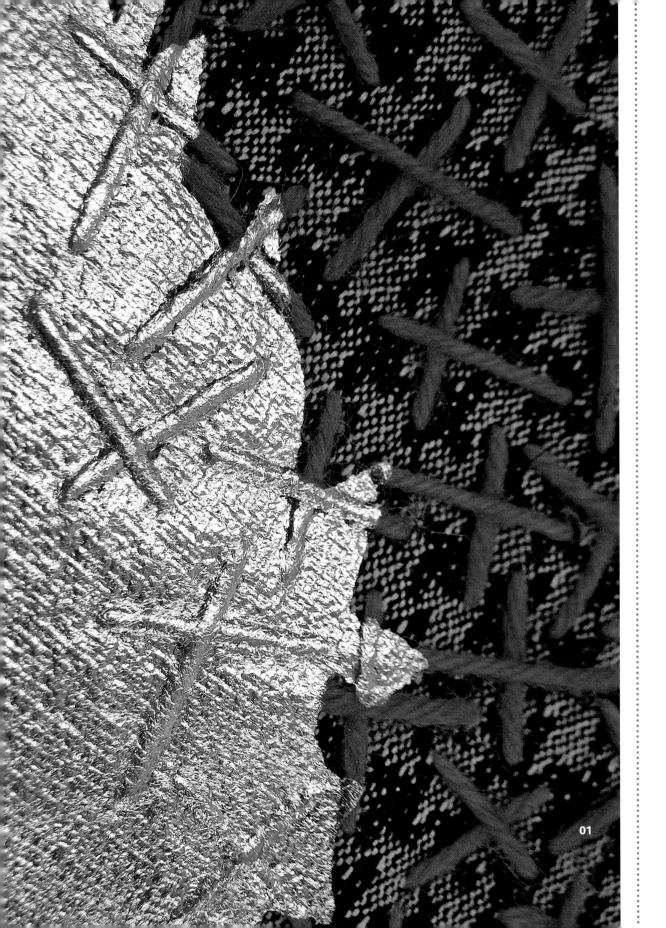

Foiling

6

What is foiling?

Foiling is the application of metallic film to fabric or other surfaces (e.g. paper or wood). Foils are produced in an extensive range of colours and styles (including shiny, matt and holographic). This chapter explains how to make a foil print and explores ways to experiment further with the foiling process. Basic foiling involves the application of foil adhesive onto fabric, either by printing a design, drawing or photograph through a silk-screen, or by painting directly onto the fabric using a brush or other tool.

To make a foil print, place your fabric onto a flat surface. Fabric can be pinned onto a backing cloth or ironed onto a gummed print table to secure it; paper or card can be taped down.

02

01 Foil print over hand-stitched embroidery on tweed,
Alison Willoughby, 2006.
Photo: Dominic Sweeney.

02 *A selection of foils and foil adhesive.*
Photo: FXP Photography.

Foil adhesive should be spooned onto the top inside edge of your silk-screen. The consistency of foil adhesive varies depending on the product used, the temperature it is stored at and its age; the pressure used will need to be adjusted if adhesive is thick and difficult to print with.

Using a squeegee and a firm and even pressure, pull the adhesive across the screen between three and six times, to create a sharp print. Be careful to lift the screen immediately after printing to avoid any blurring of the design or excess adhesive sitting on the fabric.

The adhesive print must be left until it has dried completely, either naturally or by using a hairdryer or heater to speed up the process. Foils can be cut to size, but always make sure they cover the whole printed area with room to spare.

The heat-transfer press must be set to 140–160°C, and when the temperature is reached, place your printed fabric onto the bed of the press, laying the foil sheet, with the shiny side up (or matt side down), over the print. You must then completely cover your work with Teflon™ or newsprint paper. Afterwards you can press the fabric for 10 to 20 seconds. Times and temperatures can be tested for optimum results, as they vary depending on products and materials used.

Once pressed, remove the fabric from the press and wait for the foil to cool before peeling away the excess, leaving a positive foil print on the fabric.

03 *A student peeling away foil backing during a workshop at Thelma Hulbert Gallery in Honiton, Devon. Photo: Dawn Dupree.*

04 **Untitled (party), James Unsworth, 2006.** *Foiling onto crushed velvet, 96 x 71.5 cm (37¾ x 28 in.). Photo: James Unsworth.*

05 *Samples of hand-painted foil print on wadding, wool and felt, by Dawn Dupree. Photo: FXP Photography.*

03

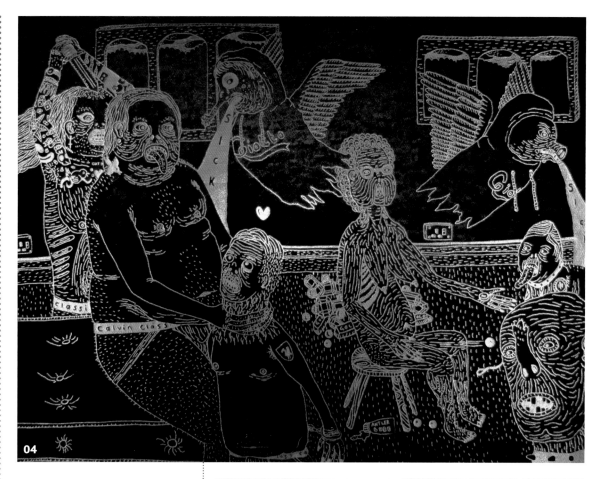

04

Foil prints can also be produced using an open screen to create a range of textures, patterns and shapes. Place a paper stencil or other resist material (e.g. muslin or cotton) onto your fabric surface prior to printing adhesive through an open silkscreen. The silkscreen can be simply constructed by stapling curtain voile over a wooden frame (see Chapter 5, Silkscreen Preparation).

Lift your screen immediately after printing, and dry adhesive completely before applying foil using the heat-transfer press.

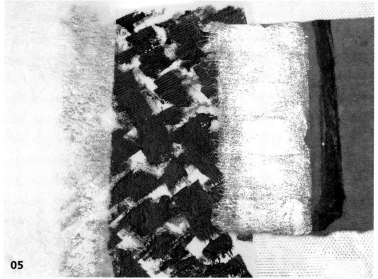

05

06

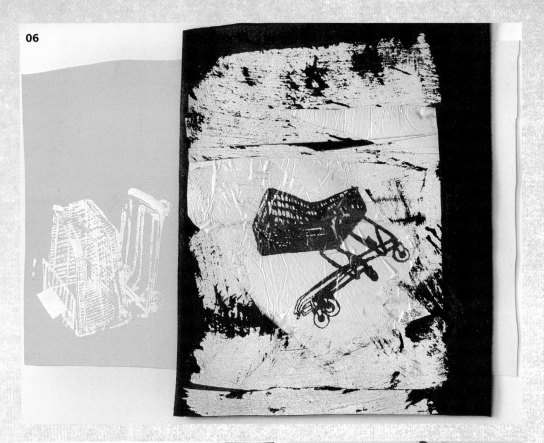

07

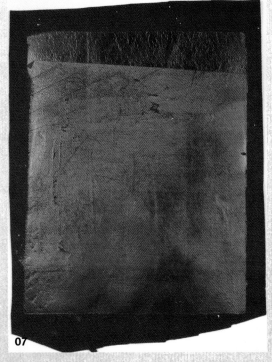

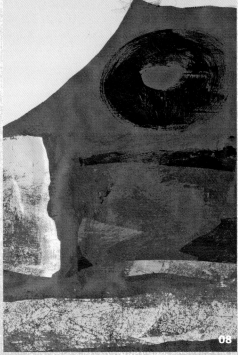

08

06 *Samples of positive silver foil print on latex and negative pewter foil print on neoprene, by Dawn Dupree. Photo: FXP Photography.*

07 *Sample red foil print on felt, by Dawn Dupree. Photo: FXP Photography.*

08 *Sample black and white foils on raw silk, by Dawn Dupree. Photo: FXP Photography.*

Foil adhesive can also be applied to fabric using a paintbrush or other mark-making tool. If this method is used, you should flatten the adhesive using a dry brush, before drying. The process can then be continued as with the printing method (see p.32). Interesting hand-drawn or textured marks can be achieved in this way. Alternatively, you could apply your adhesive using block-printing methods.

The domestic alternative to making foil prints without a heat press is to use an iron. For designs smaller than the surface of an iron, place some fabric (e.g. calico) on top of your foil and press firmly, keeping the iron moving to prevent any burning. This can be very successful with small foil samples. It is also a good method to use when applying foil to paper or card surfaces (which are otherwise unable to withstand the heat from the press).

Experiment with length of ironing time, to begin with trying a short period, e.g. 10 seconds, then removing the iron to see if the foil has become attached. If not you can press for longer until the foil is attached, and then cool before peeling off the excess foil.

Variations, alternatives and distortions

A multicoloured design can be constructed by placing several pieces of different-coloured foils over your design so that they overlap. Foil can be distorted before being heat-pressed onto fabric by being scrunched up and creased in your hand. This creates a more distressed-looking surface and is a useful source for further experimentation. Also try mark-making into the wet foil adhesive prior to drying. Pressing times and temperatures can be adjusted and experimented with to allow more or less foil to become attached to your glued surface. Try using an iron to give you more control.

Once the negative foil print has been produced, you can reuse the negative sheet in a number of ways (e.g. by either printing or painting adhesive onto your fabric and drying, then placing foil coloured side up and heat-pressing for 10 to 20 seconds, cooling and peeling the foil sheet away. Another way is to use the negative sheet and press onto a printed adhesive design, from which a fragmented design will result.

Alternatively, you can use Bondaweb™ or another adhesive web (available from most haberdashery/fabric shops) to make a negative foil print. Firstly, you must lay a sheet of Bondaweb™ (large enough to accommodate your design) onto your fabric. Lay your negative foil on top, and cover with Teflon™ if using a heat-press, or baking paper when using an iron. Once exposed to heat during pressing, Bondaweb™ or foil glue can distort the surface of your fabric, often leaving a sheen and making it stiffer to handle. This can be used to your advantage when you want a clear, shiny surface but don't want to use clear foil.

Further experiments

If you only have access to a small heat press, by heat-pressing one section at a time sheets of foil can be used to cover larger areas of fabric.

Really interesting results can be achieved when foiling smooth, textured, patterned or uneven fabrics. Patterns or textures can partially show through the foil depending on its translucency. The handle of the fabric can be transformed from delicate to robust.

Foils can also be heat-pressed over embossed or heat-set fabric surfaces for fantastic results. Also, try foiling on top of a stitched surface to exaggerate a relief pattern.

Objects or fragments of fabric, thread or paper, etc. can be embedded into the foil adhesive prior to drying (or try layering them on top after drying). Then you can place your fabric in the heat press and lay foils (shiny side up), cover with Teflon™ and press for 10 to 20 seconds. This can produce interesting and unique textured/relief foil prints.

Foiling on top of pigment-printed dyed or patterned fabrics can create beautifully layered surfaces. Foils will often stick to pigment prints in a fragmented way, especially opaque prints with a tacky or plastic-feeling surface, which can create unexpected results. Similarly, foils sometimes fuse (either partially or completely) to certain fabrics, especially those with a high plastic content. As a result sometimes foil backing cannot always be successfully peeled away, but this can result in an interesting surface.

As foiling adds weight to the surface of your fabric, try adding foil to lightweight or translucent fabrics. Experiment with foiling on both sides to alter weight and translucency further.

09 Black and white foiled dress, Jonathan Saunders, Autumn/Winter Collection 2010. *Photo: Chris Moore @ Catwalking.*

10 Foil-printed skirt, Alison Willoughby, 2005. *Upholstery cotton, foil and kites. Photo: Dominic Sweeney.*

11 *Selection of samples of open-screen foil prints on cotton, raw silk and felt, by Dawn Dupree. Photo: FXP Photography.*

12 Foil print over hand-stitched embroidery on tweed, Alison Willoughby, 2006. *Photo: Dominic Sweeney.*

13 Morphic damask hand-printed wallpaper using pigments and foil, Linda Florence, 2006. *Photo: Linda Florence.*

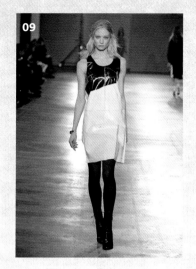

09

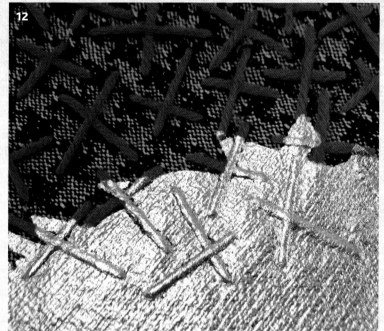

12

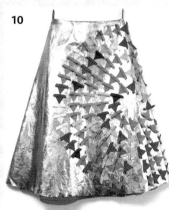

10

11

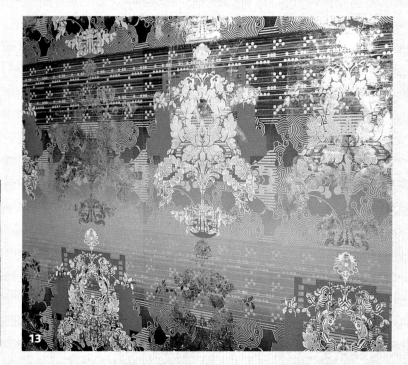

13

All these ideas, suggestions and possibilities need to be experimented with and will achieve interesting results.

14 *Samples of white foil print on silk and silver foil print on voile, by Dawn Dupree. Photo: FXP Photography.*

Notes and pitfalls

When creating a multicoloured print with several pieces of foil, take care to ensure the fragments overlap on the back, to avoid any seam lines showing on your design. This also applies if you are using small pieces of the same colour to create a layered design.

However, if a piece of foil falls away before cooling and has not yet stuck to your design, you can put it back in the press and apply heat for longer. You may need to apply more adhesive, but will need to experiment to find what works best.

Although for best results foil adhesive should be applied to create a surface that is even, flat and not too thick, to achieve different results you can experiment with the thickness of adhesive or the amount of time your design spends in the press.

To avoid foil sticking to any pigments or unwanted areas, where necessary cut the foil to size and approximate shape.

Foils can be used time and time again until your foil paper is completely exhausted, leaving you with a clear plastic sheet.

Project ideas and suggestions

Clothes can be easily customised by adding areas of foil print. Try foiling onto leather or suede for interesting results.

Try applying foil adhesive using brushstrokes onto small stretched canvases (available from most art shops). Place books covered with thick fabric for protection underneath your canvas. Lay foil over dry adhesive and cover with thinner fabric. Iron firmly across your canvas until the foil sticks, to create abstract or textured artwork.

Washing foil prints

I tend to treat foil prints as delicates – i.e. I wash them by hand and in cold or lukewarm water so that they last. They can also be machine-washed but may not last as long (the surface may start to break down sooner).

Ironing foil prints

To avoid damage to the foil surface, it is best to iron your fabric on the reverse. However, if you wish to distress the surface, applying direct heat can be used to your advantage.

15 Foiled kidskin boot, Nicholas Kirkwood, Autumn/Winter Collection 2009. *Photo: Nicholas Kirkwood.*

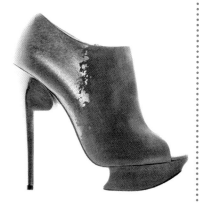

Flocking

7

Flocking is the application of a raised, velvet-like surface. It is often used for printing designs onto fashion fabrics, wallpaper and textile art.

This chapter will look at ways to print a flocked design, as well as ideas for experimenting with flock paper and flock printing. Flock printing can be used in a number of ways to apply a textured surface to fabric or another substrate.

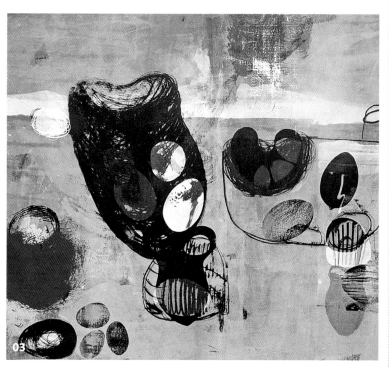

01 *Meta Table Setting*, Linda Florence, 2009. *Flocked floor installation at the Millennium Gallery, Sheffield. Photo: Linda Florence.*

02 Black foil print on black cotton (shirt under gilet), Jennifer Lapsley for Heikki Salonen at London Fashion Week, 2009. *Photo: Olle Borgar.*

03 *Material*, Dawn Dupree, 2009. *Dye paste, pigment and flock-printed linen, 19 x 11.8 cm (48 x 30 in.). Photo: Dawn Dupree.*

Basic flocking involves the application of flock adhesive onto fabric. This can be achieved by printing a design using a silkscreen or by hand-painting directly onto the fabric.

Lay your fabric onto a flat surface. Fabric can be pinned onto a backing cloth or ironed onto a gummed print table to secure it. Place your silkscreen onto the fabric and spoon flock adhesive onto the top edge inside the screen. Using a squeegee and an even pressure, pull the adhesive across the screen between three and six times.

You'll find flock adhesive is much thicker than other pigments or dyes used in printing, and needs a firmer pressure to create a nice, even print. Ideally, a successful flock print will be not too thick or too thin. However, the relative thickness of the adhesive can be varied and experimented with according to the density or translucency you are seeking in the finished print.

The adhesive print should be left to dry either naturally (this can take between 30 minutes and three hours depending on temperature and conditions) or by using a hairdryer for quicker results. It is not advisable to dry using a baking machine. When the adhesive is completely dry you can cut a piece of flock paper big enough to cover the printed area.

04 *Selection of coloured flock papers and flock adhesive. Photo: FXP Photography.*

05 *It's never black and white,* **Dawn Dupree, 2008.** *Dye paste, pigment and flock-printed furnishing satin, 40.5 x 40.5 x 6 cm (16 x 16 x 2½ in.). Photo: FXP Photography.*

The heat press should be set to 180°C, and your fabric can be placed onto the bed of the press, adhesive side facing up. The flock paper should be placed textured/coloured side facing down on top of your print, and finally this should be covered with a Teflon™ sheet or with newsprint paper, before being heat-pressed for 20–30 seconds. Remove from the press and wait for the flock to cool before peeling the paper backing away.

To print a design, texture or pattern using an open screen, first place the paper stencil or resist (e.g. muslin or leaves) onto fabric, then place the screen on top and print the adhesive through it a few times. Dry your print thoroughly, lay flock paper face down on top and heat-press as above.

Adhesive can also be applied to the surface of fabrics using a brush or other object/tool to create interesting handmade marks, designs and features, or for tiny details that it is not worth preparing a stencil or silkscreen for. For best results flatten the adhesive with a dry brush prior to drying.

Variations, alternatives and distortions

Different-coloured flock papers can be used together. This can be done by overlapping different sections or shapes of paper (to avoid seams showing) to create interesting multicoloured flock prints or designs.

06 *Sample of photo silkscreen flock print on Ripstop™ nylon, by Dawn Dupree. Photo: FXP Photography.*

07 *Multi-coloured flock prints on sublimation-printed paper nylon. Flag workshop at Lillian Bayliss School, London. Photo: Dawn Dupree.*

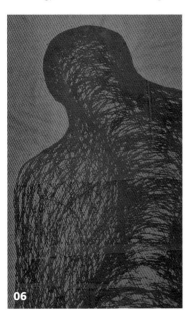

Using a thicker adhesive surface can result in a greater density of flock being removed from the flocking sheet during the heat-pressing process. However, if it is too thick it can result in paper from the flocking sheet being removed as well. You should experiment to see what works best. Alternatively, using a thinner adhesive surface can result in a more translucent flocked surface as less of the flocking is removed from the sheet.

Flock paper can be reused until all the flocked surface has been removed from the paper backing. Partly used flock sheets used in this way can create interesting, fragmented results.

Bondaweb™ and other adhesive webs can be used to print a negative flock print. First, place Bondaweb™ onto your fabric and then lay down your negative flock sheet on top, flock-side down. Cover and heat-press for 20–30 seconds to fuse.

Flocking works best on flat-surfaced fabrics, but can also be used on textured, patterned and multilayered prints. Try adding flock print on top of foil.

You can exploit the translucent quality of flock by applying adhesive to an existing printed fabric before heat-pressing it with flocked paper. Flock printing on different textured fabrics can yield some exciting results, which may see an already patterned or raised surface accentuated or distorted.

Try encapsulating objects (plants, leaves, sequins, etc.) between the flock and the fabric by embedding them, to create unusual textured, patterned surfaces with raised areas or fragments of the objects revealed on the edges of the flocked surface.

Notes and pitfalls

Take care not to peel off the paper backing too early, as it may result in a fractured, less successful flock print. Also, when making a flocked print that is larger than the surface of your heat-press plate, you can press one area at a time, being careful (if possible) not to re-press flocked surfaces, as this can flatten the raised flock or distort the velvety texture.

08 *Sample of layered pigment and digital flock-print, by Dawn Dupree. Photo: Dawn Dupree.*

09 *Sample of black and white flock print on pewter foil-printed PVC, by Dawn Dupree. Photo: FXP Photography.*

10 *Turbulence, Dawn Dupree, 2009. Dye paste, pigment and flock-printed cotton satin, 119 x 76 cm (47 x 30 in.). Photo: Dawn Dupree.*

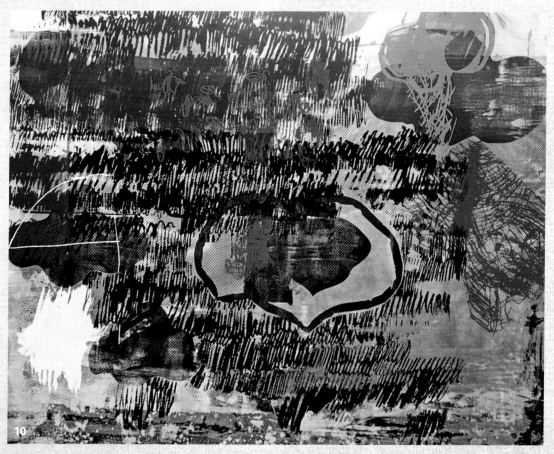

If you have any exposed adhesive, it is best to use the Teflon™ sheet as this does not stick to the surface, unlike newsprint which can be difficult to remove afterwards. If you plan to use several pieces of smaller flock to cover a larger printed area of adhesive, avoid seams by placing pieces together like a jigsaw-puzzle, making sure they are overlapping on the back, before heat-pressing.

To prevent the lighter surface showing through the flock when printing a darker-coloured design or image onto a lighter surface, mix a little of the flock adhesive in a small container with some pigment and print your design using this coloured adhesive. (But be careful not to mix more than you need.) This results in a deeper, richer flock colour.

11

11 *Fragmented flock print on a pigment-printed cotton sample made by a student at London Printworks Trust. Photo: Dawn Dupree.*

12 Black flock print (black pigment in flock adhesive) on white suiting wool, Jennifer Lapsley for Heikki Salonen at London Fashion Week 2009. *Photo: Olle Borgar.*

12

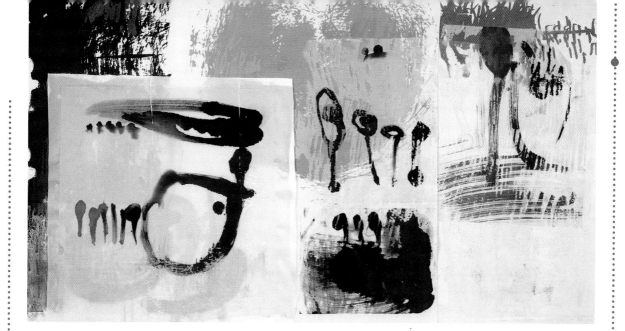

13 *Sample white flock print hand-painted with fabric transfer inks, by Dawn Dupree. Photo: FXP Photography.*

When using flock on an already printed surface (e.g. pigment), you will need to cut the flock (first turning it over) in a roughly similar way to the adhesive print to prevent too much extra flock sticking to the pigmented surface. If some flock does adhere outside the parameters of your design, you can try to rub off any excess on the print surface with your hand. You can also try using tape, which is similarly useful for removing any dust or fragments that have stuck to your flock print.

Further experiments and methods for colouring flock paper

Flock can be bought in a wide range of colours and styles. However, you can also experiment with various ways of colouring or patterning white polyester flock paper produced specifically for this purpose. Below I have outlined a number of methods for you to experiment with further.

1. Transfer inks – dye sublimation

Sublimation transfer inks can be applied to the surface of white MCP flock paper to create beautiful hand-painted designs that can then be heat-pressed onto fabrics. Where you leave areas of flock unpainted a white flock will be transferred. This method has a semi-translucent quality to it and allows colours from the background fabric to partially show through. This can be used to complement printed fabric layered with flock prints. Try painting onto negative polyester flock paper with transfer inks or disperse dyes for an alternative, fragmented flock print.

2. Dye print or paint

Plastic-coated white polyester flock paper can be dyed using disperse dyes. Heat enough water to submerge your paper in a metal bucket to 90°C (194°F), then sprinkle disperse dye on the surface of the water and stir thoroughly. You can experiment with different amounts of dye to create the depth of colour you require. Then place sheets of polyester flock into your dye bath and move them around continuously for five minutes. Leave the sheets to absorb the colour for a further 20–30 minutes depending on the shade required, before removing them from the dye bath and drying them (on a line or on newspaper).

Disperse dyes can also be painted directly onto the surface of the flock sheet, which once dried can be heat-pressed onto your fabric. To prepare for painting, mix a spoonful of disperse dyes with a few drops of cold water and mix to a paste in a small container. Add boiling water and stir to dissolve the paste. Add more cold water to dilute the colour. Wear gloves and a mask to prepare.

14 *Hand-painted multicoloured flock T-shirt, by a participant from 'Theatre of the Making' Crafts workshop, 2008. Photo: Dawn Dupree.*

3. Sublimation papers

White polyester paper can be heat-pressed with sublimation papers (bought or hand-painted) before being used as a flock-printed surface.

4. Pigment print

Paint or print onto the surface of white flock paper using pigments. This can distort the flocked surface, but can also create unusual flock prints.

Washing flock prints

Fabrics with flocked prints need to be treated as delicates and hand-washed in lukewarm water. They can also be washed in a machine, but bear in mind that this could accelerate their deterioration. Once washed, dry fabrics and iron on the reverse.

15 *Samples of flock print on felt, linen and cotton, by Dawn Dupree. Photo: FXP Photography.*

Ideas for projects

Flock printing could be used to embellish an existing garment, bag or cushion. Small areas of flock can create richly contrasting textures and colours. Try printing a simple flock design, a pattern or a simple motif, onto a heavy linen or furnishing fabric. This could then be sewn into a cushion or used to cover a chair or lampshade.

16 *Tiled Location*, Dawn Dupree, 2008. *Dye paste, pigment and flock-printed furnishing satin, 58.5 x 38 cm (23 x 15 in.). Photo: FXP Photography.*

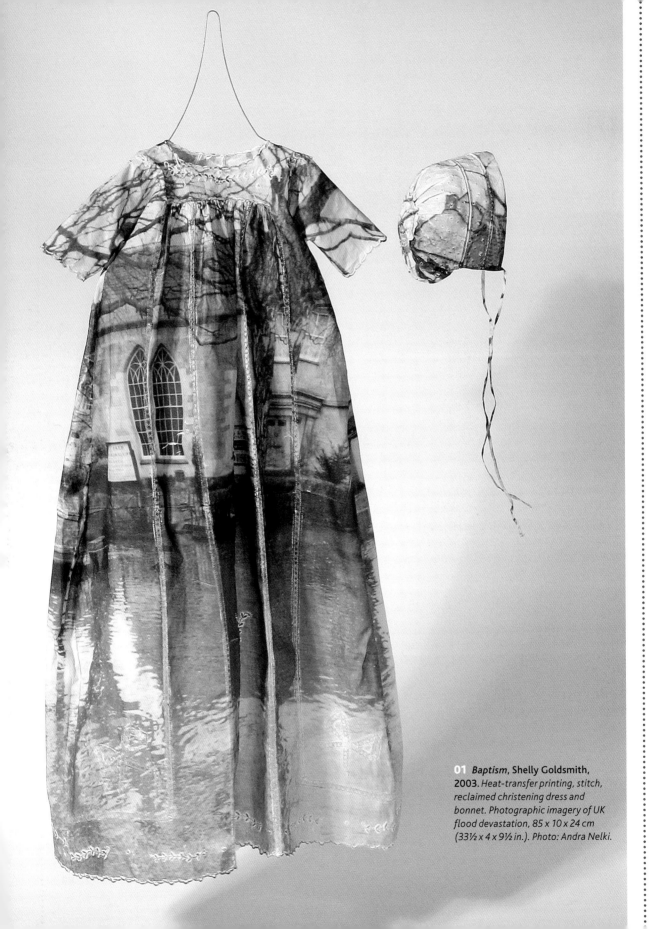

01 *Baptism*, **Shelly Goldsmith, 2003.** *Heat-transfer printing, stitch, reclaimed christening dress and bonnet. Photographic imagery of UK flood devastation, 85 x 10 x 24 cm (33½ x 4 x 9½ in.). Photo: Andra Nelki.*

Photo transfer

8

What is photo transfer?

This process involves a full colour image being digitally printed onto photo-transfer paper using an inkjet printer. This is then transferred onto fabric using a heat-transfer press.

The photo-transfer process is commonly used as an alternative to a more labour-intensive multicoloured printing process to create coloured designs on T-shirts and other surfaces. This process is often available in photocopy shops. However, some photo transfers can be crude, imparting a plasticky surface to the heat-transfer design. Photo-transfer paper (sometimes called T-shirt transfer paper) is available from a number of suppliers in a range of qualities with which you can experiment to achieve diverse results. Photo-transfer paper comes in two basic types:

a) for white or light backgrounds
b) for dark backgrounds.

A photo-transfer design can be produced in various ways using your computer. The end result needs to be saved and printed onto photo-transfer paper using an inkjet printer. Designs can be generated on your computer using Photoshop, Illustrator or other programs.

02 *A selection of materials used for photo-transfer printing. Photo: FXP Photography.*

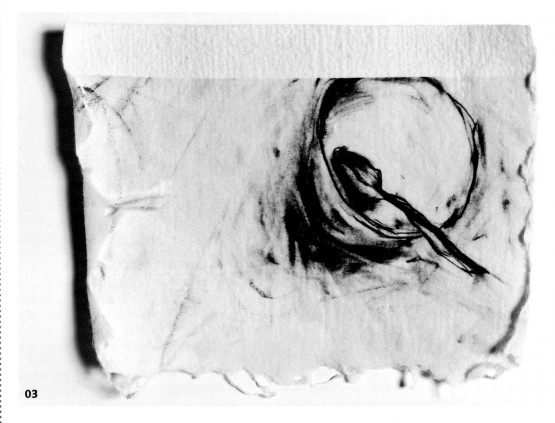

03

Any source material – including drawings, paintings, postcards and fabrics – can be scanned and saved on your computer before being printed onto photo-transfer paper. Any designs scanned in this way can be further manipulated in Photoshop or other programs in a number of ways.

All designs need to be flipped horizontally on your screen, before being printed onto photo-transfer paper. This will ensure the design is pressed onto the fabric or T-shirt the right way round. This is particularly important when using text.

It is sometimes advisable to lighten your design before printing onto paper as photo transfers can be darker than the original design. Most suppliers include instructions, but it is still a good idea to experiment to get the best results.

It is really important to use a white or light background with this process (unless you're using dark photo-transfer paper) as the coloured design you create will absorb any colour in the background as soon as the white paper backing is removed.

03 *Sugar and Spice...*, **Heather Belcher, 2008.** *Scanned drawing onto heat-transfer paper and printed onto handmade felt, 40 x 30 cm (16 x 12 in.). Photo: David Ramkalawon.*

04 *(left to right):* ***Spreckley 1***; ***Lumley***; ***Spreckley 2***, **Paddy Hartley, 2007.** *British Army officer jackets, cotton thread, vintage lace, Lazertran, leather. Digital embroidery, appliqué, inkjet print on Lazertran for dark fabric. Museum of Arts and Design New York (Lumley); The Wellcome Collection (Spreckley 1 & 2). Photo: Paddy Hartley © 2008.*

05 *Photo-transfer prints onto a selection of fabrics. Photo: FXP Photography.*

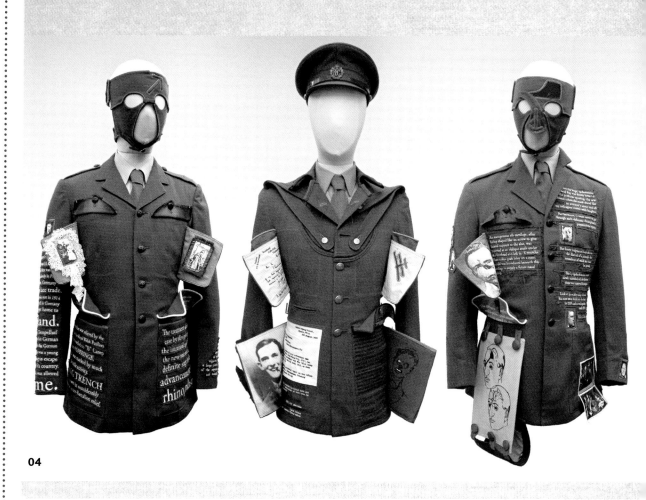

04

05

Photo-transfer method onto a white/light background

▶ Print your inverted design onto photo-transfer paper, making sure you print onto the correct side of the paper.

▶ Cut off any excess white paper, or cut around your design.

▶ Lay your fabric or T-shirt on a heat-press plate. Place your photo transfer face down onto the fabric or T-shirt and cover with Teflon™ sheet or newsprint.

▶ Press for 20 seconds at 180°C (or the length of time and temperature specified on the product) in your heat-transfer press, then peel off the backing immediately (unless instructions state 'cool peel', in which case you must wait until the transfer is cool to remove the backing).

Applying a photo transfer to a dark background

Instructions are included with every photo-transfer product, but please note the following:

▶ You do not need to invert your image when using this paper.

▶ You must print your image onto the white side of the transfer paper and wait five minutes for it to dry.

▶ Cut off any border around your design and remove the silicone backing from the printed film.

▶ Take care with the film to avoid scratching or creasing.

▶ Place your design face up on top of your T-shirt or fabric and cover with a Teflon™ sheet (or baking paper if using an iron).

▶ Heat-press for 10–15 seconds.

06 *Leopold Gold*, Natasha Kerr, 2005. *Hand-painted, silkscreen-printed, transfer-printed, appliquéd and hand-stitched fabrics, 142 x 80 cm (56 x 31½ in.). Photo: Natasha Kerr.*

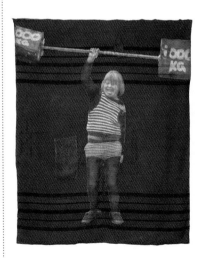

07 *World's strongest man (one hand only)*, Silja Puranen, 2007. *Fabric paint, transfer photograph, soft pastel and stitching on found textile, 195 x 155 cm (76¾ x 61 in.). Photo: Johnny Korkman.*

Alternatives, experiments and suggestions

Photo-transfer paper usually comes in A4 size but can also be bought in A3 (although you will need access to an A3 inkjet printer to use this size). Designs may be printed using the full A4 surface, or you can print a number of designs onto a single sheet. Shapes can be cut out of an abstract design and smaller images can be cut around prior to heat-pressing. If you decide to use this process to heat-press several small fragments or designs, make sure you can peel off the paper backing quickly after heat-pressing, or have someone on hand to assist you.

Photo-transfer designs can be used on a range of fabrics to create many different outcomes. Experiment with textured, shiny, synthetic and natural fabrics to produce various surfaces.

08 *Samples of oil pastels drawn onto plain photo transfer paper, and photographs printed onto photo transfer paper, on cotton, by Dawn Dupree. Photo: FXP Photography.*

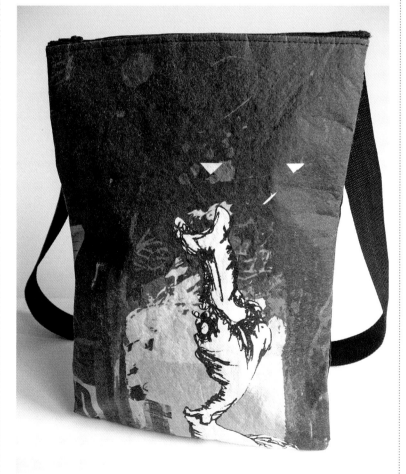

09 *Urban Alien Bag, Ann Therese Yndestad, 2009. Collage of drawing and photography; photo transfer on felt, 25 x 36 cm (10 x 14 in.). Photo: Ann Therese Yndestad.*

Interesting results can be achieved by layering photo-transfer designs on top of fabric already printed using dyes or pigments. Transfer designs will blend into coloured pigment areas, giving a more subtle result, and stand out on unprinted or light-coloured areas of fabric. Experiment with different printed fabrics to see what works best.

It is also possible to print or paint on top of photo transfers using pigments, etc. and use other materials to distort or manipulate your design.

When creating your original photo-transfer design, you could try collaging hand-drawn and photographic designs together, manipulating colours, distorting shapes or changing scale. These effects can be achieved using Photoshop or other computer programs.

10 Sample of abstract photo transfer on hand-printed linen, by Dawn Dupree. Photo: FXP Photography.

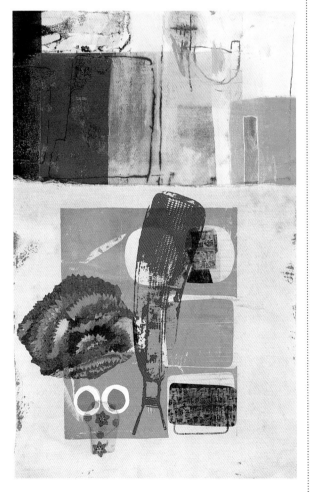

11 Sample of layered photographic and hand-drawn photo transfers on dye-paste and pigment-printed cottons, by Dawn Dupree. Photo: FXP Photography.

Oil pastels can be used to draw directly onto the plain photo-transfer paper instead of using an inkjet printer. This can create interesting results, and is useful when a printer is unavailable. Once you have applied your design (remembering that it will be reversed) you can cut out the shape of paper you wish to press and proceed as before, placing the design face down on your fabric and heat-pressing for 10–20 seconds, then peeling backing away immediately, if hot peel. In the same way you can also draw on top of a printed photo-transfer paper with oil pastels to create an interesting and combined digital and hand-drawn image
or design.

Objects can be incorporated beneath photo-transfer prints to create textured or distorted surfaces. Experiment with laying objects (e.g. leaves, sequins or fibres) onto fabric before placing photo-transfer paper on top. Times and temperatures of heat-pressing can be adjusted to interfere with the process, sometimes creating fragmented or distressed results.

12 *Collage of oil pastels and photo transfers on paper nylon, canvas and satin, by Dawn Dupree. Photo: FXP Photography.*

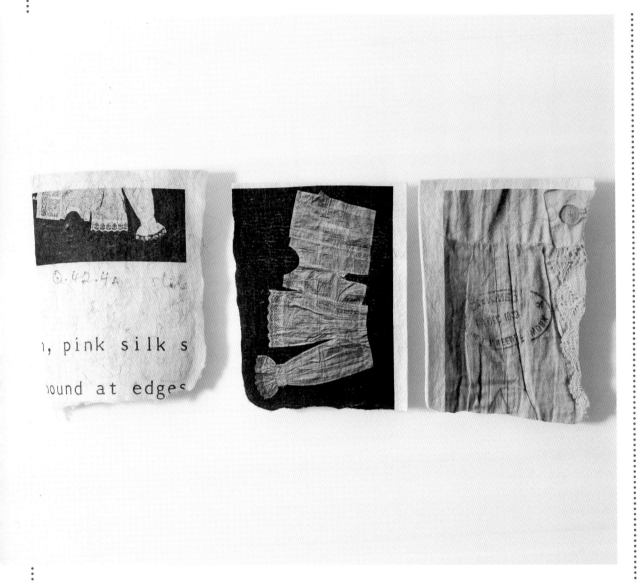

13 *Pink Silk*, Heather Belcher, 2005.
*Photographic image on heat-transfer
paper, printed onto handmade felt.
Photo: David Ramkalawon.*

Notes and pitfalls

Photo transfers can be ironed onto your fabric surface, but you must cover your work with fabric first. Try to keep an even pressure on all areas, and keep checking to see if the transfer has attached. This method works best for small designs (A5 or less).

If you do not peel off the paper backing quickly enough (for hot peel), you risk the paper becoming stuck and you will be unable to remove it. Small areas that remain after the main backing has been peeled away can subsequently be picked off, or dampened then removed.

If you lift the paper backing too quickly and at a sharp angle, as opposed to gently peeling it away, you may risk tearing or lifting your heat-press image. This can sometimes be remedied by laying it back down and pressing again for a few seconds, or alternatively by gently starting to peel from the other side of the paper.

A photo transfer is often left with a plastic feel to its shiny surface. To reduce this, put the fabric in the heat press with the design face-up. Cover it with Teflon™ and re-press for two to three seconds. Experiment with this as variables in paper, fabric, etc. can yield different results.

Washing photo-transfer designs

Photo transfers need to be treated as delicate and hand-washed in cold or lukewarm water.

Suggested project

Taking images drawn directly onto photo-transfer paper with oil pastels, or a drawing executed on another substrate but printed out on photo-transfer paper, heat-press the photo-transfer paper with the hand-drawn images onto a plain canvas bag for a unique product.

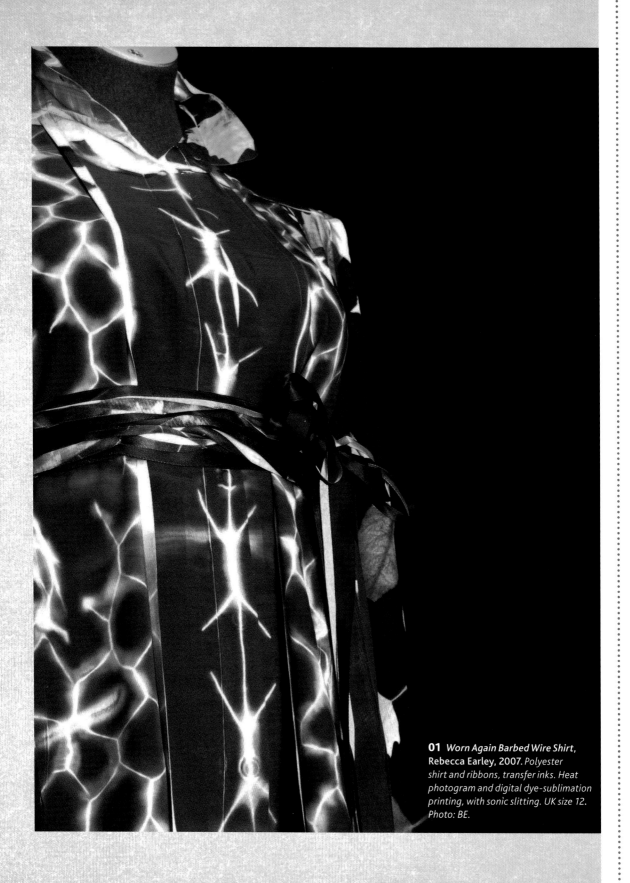

01 *Worn Again Barbed Wire Shirt*,
Rebecca Earley, 2007. *Polyester
shirt and ribbons, transfer inks. Heat
photogram and digital dye-sublimation
printing, with sonic slitting. UK size 12.
Photo: BE.*

Dye Sublimation

9

What is dye-sublimation printing?

Sublimation printing is the process by which disperse dyes are transferred from paper to synthetic fabric, or another polymer-coated surface, using a heat press. Disperse dyes can be painted or printed onto paper, which is then placed face down onto the fabric. This is then sandwiched between newsprint or Teflon™ and placed in a heat press for anything from a few seconds to two minutes, depending on the depth of shade required. A domestic iron can be used as an alternative.

Sublimation occurs at 180–200°C (356–392°F) when the dye is converted from a solid to a vapour and back again into a solid as it cools down. At this temperature the dye loses its affinity for the paper (preferring the fabric), allowing the design to transfer. Disperse dyes are fixed at this temperature and do not need further steaming.

02 Selection of products and materials used for dye-sublimation printing. Photo: FXP Photography.

03 Selection of samples of sublimation-prints on Kurtex, by Dawn Dupree. Photo: FXP Photography.

04 *Satin acetate sample by Ricardo Matos. Clear latex was dyed with disperse dyes to produce the sample. The sample was then scanned to produce a digital file. The digital file was printed with sublimation dyes onto paper, and transferred using a heat press. Photo: Ricardo Matos.*

05 *A selection of digital sublimation prints on Ripstop™ nylon on a light box (work in progress), Dawn Dupree, 2009. Various sizes. Photo: Dawn Dupree.*

Sublimation processes

There are a number of ways to experiment with sublimation printing, and many products are available. The basic method involves placing sublimation paper (plain, painted or printed) directly (i.e. coloured side down) onto polyester (or another manmade fabric) or a polymer-coated surface. This is then heat-pressed for between approximately 10 to 90 seconds at 180–200°C (356–392°F).

There are a variety of ways of using sublimation printing, from very simple ideas to more complex methods. Some of the following processes can be combined and experimented with to create an infinite range of exciting possibilities and outcomes.

Disperse dyes in solution are the only dyes that sublimate at 180–200°C (356–392°F), so no other dye range can be used on this process. Disperse dyes are only suited to man-made fabrics, though other fabrics and specially coated surfaces (see 'Surfaces to transfer sublimation prints onto', p.81) can be experimented with: in particular mixed-fibre fabrics, where the dye may transfer to the synthetic fibres and/or stain the other, natural fibres. If you're using natural fibres with this process (e.g. cotton) the dye may colour or stain the fabric a paler shade, but it is possible that your design could disappear if washed.

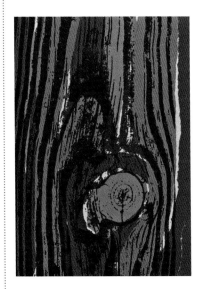

06 *Sample of woodgrain sublimation, by James Bosley. Sublimation print and papers on poly crêpe, approx. 30 x 42 cm (12 x 16½ in.). Photo: James Bosley.*

There are many variables to consider when using this process, including the type of synthetic fabric used (all respond differently), the depth of shade used, the time taken to press the dyed paper onto the fabric, and the intensity or subtlety of colour (dye or transfer paint) used to print or paint onto the paper.

Option 1: Sublimation papers

Manufactured sheets of sublimation paper come in a range of colours and can be purchased by the metre. I have used papers from Penny Marriott in my samples, but you may find or want to use other suppliers (some may have a minimum order requirement).

Sublimation papers appear dull compared with their true colour, which is revealed by heat-pressing. (You can test them by cutting small samples of sublimation paper, and heat-pressing for a range of timings at 180–200°C (356–392°F) onto fabric samples to indicate actual colours (always allowing for the fact that different types of fabric yield varying results, etc.).

Ideas for using sublimation papers (stencils, backwards, resists, photocopies)

Shapes or stencils can be cut out of sublimation papers before being heat-pressed onto fabric. Designs can be built up by heat-pressing several shapes, allowing colours to overlap and mix on the fabric.

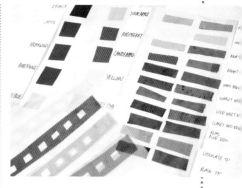

07 Colour tests on satin acetate (bought sublimation paper), nylon (dye-painted paper) and Ripstop™ nylon (overlaid transfer paints). Made by Fiona King, assisting with research at Dawn Dupree's studio, 2010. Photo: FXP Photography.

08 Samples of sublimation paper printed with pigment and heat-pressed onto polyester/curtain netting printed with sublimation paper, by Dawn Dupree. Photo: FXP Photography.

This can be varied greatly according to the colours of paper used, the length of time they are pressed for and the colour of the synthetic fabric they are applied to.

To produce a more complex design using sublimation paper, you can print onto the dyed surface of the paper using opaque pigment with a silkscreen (opaque binder used for screenprinting mixed with concentrated pigment or ready-mixed opaque colours). This design will be reversed when heat-pressed onto your fabric, so to allow for this you could expose a negative design onto your silkscreen before printing it onto sublimation papers.

Alternatively, different elements of a design can be printed onto different, coloured sublimation papers to produce a multicoloured design, once each paper has been heat-pressed onto your fabric. After you have printed and dried the sublimation paper, it can be heat-pressed onto the fabric for between 2 and 90 seconds.

The opaque pigment print acts as a resist, in a similar way to a stencil, resulting in a negative sublimation print of your silkscreen design. However, the longer it is pressed for, the more the contrast is reduced, as on longer settings the dye will partially print (a diluted shade) through the opaque pigment. Experiment for different results.

09 *A selection of materials (stencils, feathers, lace, netting, etc.) that can be used as a resist during sublimation printing. Photo: FXP Photography.*

10 *Samples of sublimation-printing on coloured and white synthetic felt using rubber bands and feathers as resist, by Dawn Dupree. Photo: FXP Photography.*

11 *Samples of sublimation-print on various synthetics, using transfer paints and sublimation paper, by Dawn Dupree. Photo: FXP Photography.*

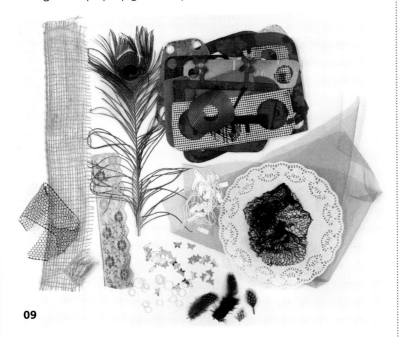

09

10

11

The sublimation paper can be used over and over again, producing paler shades with each application.

Papers can also be pressed partially face down, with some of the paper face up, to create interesting, grainy or seemingly three-dimensional results.

Once your fabric is on the heat-press plate, flat objects can be placed onto the fabric to act as a resist to the colour of the sublimation paper. Experiment with a selection of things including, doilies, leaves, rubber bands, lace, threads, feathers or sequins (available in most haberdashery or stationery shops). Then you need to cut the sublimation paper to cover the fabric and place it face down over the objects. Cover this with newsprint and heat-press for between 20 and 120 seconds (varying according to the depth of shade you require). The objects will resist the sublimation paper, resulting in a negative image or design being produced (like a photogram). The sublimation paper can then be re-pressed onto another fabric sample to create a positive design.

Also, objects used as a resist in this way can be turned over and pressed again onto more fabric. This is because dye from the sublimation papers will have been transferred onto the objects during the heat-pressing process.

Alternatively, stencils cut from newsprint can be used to resist the dye. However, if the sublimation paper is pressed for longer than 60 seconds, dye will start to bleed through the newsprint, though this can also create a beautiful, pale and grainy effect. Multicoloured sublimation prints can be constructed by using a different stencil for each colour and heat-pressing one colour at a time.

Sequins can sometimes melt and become attached to the fabric during this process if pressed for a longer time. This can yield interesting results with coloured sequins patterning dyed blocks of colour.

Another way to use the above method is to collage a selection of objects onto a board, which gives greater stability for the positioning of objects. For example, threads can be taped taut (on the back of a piece of card) and objects can be glued to secure them. Sublimation paper can be placed face up under the objects and fabric can be placed face down onto them. This can then be heat-pressed for anything between 2 and 120 seconds. Then remove the fabric to reveal your design.

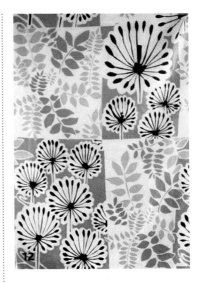

12 Heat-transfer papers printed through a hand-cut stencil onto a taupe linen-mix fabric (part of a collection based on Art Nouveau), Penny Marriott, **2009.** *50 x 80 cm (19¾ x 31½ in.). Photo: Penny Marriott.*

13 *Sublimation samples using resist objects made by a student on a workshop led by Dawn Dupree. Photo: Dawn Dupree.*

14 *Samples of sublimation prints using positive and negative photocopies on polyester by Dawn Dupree and Fiona King. Photo: FXP Photography.*

You can experiment by placing your sublimation paper face down on top of objects and pressing in the heat press for approximately 60 seconds. Then remove your pressed sublimation paper, place it face down onto the fabric and press again for 20–120 seconds. This will create a negative print of your design. Objects pressed with the sublimation paper will have retained the dye from the paper, and can therefore also be pressed onto the fabric to create positive designs.

Black and white photocopies of a drawing, design or photograph can be used to create an interesting and detailed sublimation print. This is achieved by placing your photocopy face up on the heat-press bed, placing sublimation paper face down (colour side down) onto the photocopy and pressing for between 30 and 60 seconds.

Once cool, peel the paper away from the photocopy. You'll notice that during this process some of the dye from the sublimation paper will have been transferred to the photocopy. Afterwards you can lay synthetic fabric (or another sublimation surface) onto the heat-press

bed, place your photocopy face down onto the fabric and press for 60–120 seconds. This results in a coloured print of your photocopied design. You can also press the sublimation paper onto more fabric to create a negative print of this design.

This method can be pushed further by repeating it with another colour on part of the same photocopy. Colours mix on overlapping areas to create interesting results. However, it only works with a photocopy, and does not apply to an inkjet-printed image. Outcomes vary according to the type of photocopier used.

You can also paint directly onto your photocopy using disperse dyes or transfer inks, which can then be dried and heat-pressed onto fabric for between 20 and 120 seconds. This method allows for greater freedom to paint colours in specific areas, using your design as an outline. You must make sure you dry your painted photocopy before heat-pressing it onto your fabric.

Option 2: Homemade sublimation papers

Sublimation paper can be prepared in a number of ways including painting ready-mixed transfer inks or disperse dyes onto paper.

Transfer inks can be bought from a range of suppliers. I use Colourist fabric transfer paints, though there are several other options, including Deka™ Iron-On and Berol™ transfer paints, available from various craft suppliers (see the suppliers' list at the end of the book). Fabric transfer paints can be used to paint your design onto paper. I find non-absorbent is best, though I have also had good results when painting onto newsprint, despite the fact that it can dry unevenly. A good-quality cartridge paper (e.g. 65gsm or similar) works well.

You can be as experimental as you like, using different-size brushes, creating loose, detailed or layered designs. Play with mark-making, allowing colours to bleed into one another, and try making ink blots. Due to the translucent quality of disperse dyes and transfer paints, overlaid colours painted onto paper blend to create a range of different shades and effects. Colourist also sell extender and thickener for their transfer paints.

15 *Samples of hand-painted transfer paints heat-pressed onto polyester and nylon, by Dawn Dupree. Photo: FXP Photography.*

16 *Samples of a selection of sublimation prints on paper nylon, Ripstop™ nylon, satin and netting by Fiona King and Dawn Dupree, 2010. Photo: FXP Photography.*

You must always allow your paper designs to dry before heat-pressing them onto the fabric. Place your paper face down on top of your fabric and cover with more paper or Teflon™. Heat-press for approximately 30 seconds at 200°C (392°F); you can vary the time to accommodate different thicknesses of paper, different types of fabric, and to produce different shades of colour. If you are using an iron, a cotton setting is required.

You must remember that your design will be a mirror image once transferred to your fabric, so if you plan to write any text you need to paint any letters on your paper in reverse.

▶ NOTE

Always remember to protect your heat press when using sublimation papers, by placing paper underneath and on top of your work before pressing.

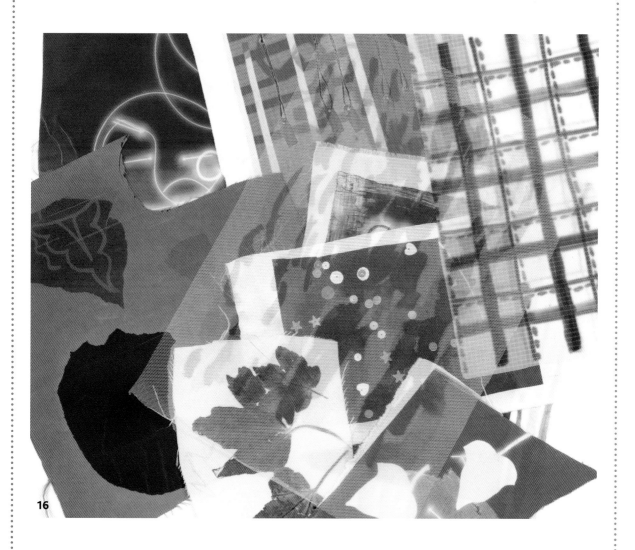

16

Crayola™ fabric crayons can be used to draw designs onto paper. Non-absorbent works best, but any paper will do. This can be heat-pressed or ironed onto man-made fibres, and is especially useful when using this method with younger children, or somewhere with limited space or resources. This type of fabric crayon can also be used to draw onto paper that has already been painted with transfer paints or disperse dyes, to add more detail.

Disperse dyes can be prepared by mixing a teaspoon of powdered dye together with a teaspoon of cold water to a paste, adding 50ml boiling water and stirring to dissolve. A dust mask and rubber gloves must be worn when preparing dyes, to avoid inhaling any dye powder or staining your hands.

Disperse dyes in solution can be kept in an airtight plastic or glass container, to be used at a later date. Make sure you label your containers with the correct dye colour. (You could also keep a small sample in a dye note book for easy reference.)

17 *Binformation*, Susan Eyre, 2008. *Reactive-dye digital print on cotton; digital print, disperse-dye heat sublimation onto polyester. The polyester is heat-fused onto the cotton using a fine-point soldering iron. 122 x 154 cm (48 x 60½ in.). Photo: Susan Eyre.*

18 *Found by the sea, almost a salt marsh*, Shelly Goldsmith, 2008. *Sublimation, embossing and dye on reclaimed garment interior, using archival pressed plant samples from the Natural History Museum's Herbarium, 24 x 31 x 2 cm (9½ x 12¼ x ¾ in.). Photo: Andra Nelki.*

▶ **NOTE**

The following is a list of suitable disperse dyes for transfer printing, available from several suppliers (see pp.118–21):

Mid Yellow EG
Bright Orange E2R
Scarlet Red EB
Fuscia Red EXB
Bright Pink EFB
Claret Red EBD
Chocolate Brown G
Dark Brown G
Vivid Violet E4R
Royal Blue EBN
Navy Mixture
Aqua Turquoise GFS
Turquoise Blue 7G
Lime Green 2G
Emerald Green G
Lincoln Green EGB
Bottle Green 2B
Charcoal Black Mix
Full Black EBT

You may find other disperse dye colours produce varying results.

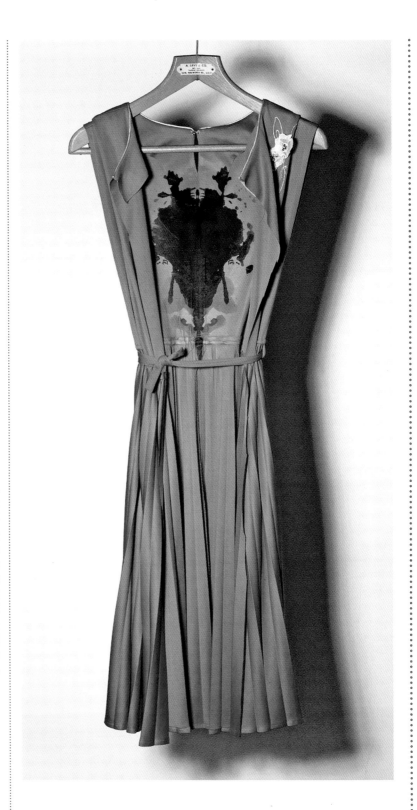

19 Erupted, Shelly Goldsmith, 2008. *Sublimation print on reclaimed garment interior. Symmetrical layers of flooded colour, influenced by Rorschach ink-blot tests, appear in the interior space of a cocktail dress. 39 x 113 x 8 cm (15¼ x 44½ x 3¼ in.). Photo: Andra Nelki.*

This dye in solution can then be painted onto paper, which should not be so thick that it prevents the dye from being transferred in the heat press. Ideally you should use 80–100gsm paper. Thinner papers also work well, though more cockling occurs. Experiment to get different results, for instance by using textured papers to create uneven or textured designs.

To adjust the depth of shade, add more cold water to dilute the dye solution further; the more water added the paler the shade of colour produced when heat-pressed. All dyes are fully intermixable, and you can use them to create an extensive range of colours by blending them together.

20 *Samples of sublimation prints with stencils and re-printed rubber bands, by Dawn Dupree. Photo: FXP Photography.*

These papers can be dried naturally or by using a hairdryer or fan heater (you must be careful not to leave unattended to avoid any fire risk).

The advantage of this method is that it enables more freedom and greater potential for experimenting with mark-making and colour mixing, as opposed to the flat sheet of colour manufactured sublimation papers provide. Homemade sublimation papers can be produced by hand-painting onto an uneven surface to create a more textured result. Painting thin or saturated areas of dye onto paper can vary this method further.

21 *Sample sublimation transfer using reprinted leaves on polyester, by Dawn Dupree. Photo: FXP Photography.*

By hand-painting papers, a unique range of patterns, designs, and images can be produced. Experiment with different brushstrokes, flicking dye, and blow-drying wet dye in various directions, overlapping colours and allowing colours to blend together.

All homemade sublimation papers can be transfer-printed in the same number of ways as manufactured papers: heat-pressed as a whole sheet of colour, cut into stencils, overlaid with flat objects to resist the dye, or sandwiched together with a photocopy (to produce positive and negative prints).

When using synthetic objects as a resist (e.g. rubber bands or synthetic lace) in this way, the objects become impregnated with dye when heat-pressed and can be subsequently re-pressed onto fabric to create interesting shaped, patterned or textured designs.

As with all these processes, the amount of time used to heat-press the paper onto fabric can be varied and experimented with, but the temperature needs to be set at a minimum of 180°C (356°F) to allow the dye to sublimate and your design to transfer onto the fabric successfully.

Option 3: Direct painting with disperse dyes and transfer inks

Disperse dyes in solution, or transfer inks, can also be painted directly onto the surface of flat objects (for example, leaves or slices of vegetables) and left to dry. These can be placed dye side down onto fabric and heat-pressed for one to two minutes to create interesting patterned and textured designs.

Disperse dyes and transfer paints can also be painted directly onto the surface of fabric. This method of direct transfer involves painting your design onto your fabric instead of paper, so less dye or transfer paint is needed. You must then heat-press your fabric once it is dry, for between 30 and 60 seconds at 200°C (392°F), to fix the dyes to the fabric.

22

23

22 *A selection of designs for sublimation, including disperse-dye screen-printed paper, pigment-printed sublimation paper, and digital disperse-dye-printed images on paper (samples), by Dawn Dupree, 2010. Photo: FXP Photography.*

23 *Collage of digital sublimation prints on paper nylon (samples), by Dawn Dupree, 2009. 30 x 30 cm (12 x 12 in.). Photo: Dawn Dupree.*

Option 4: Screenprinting with disperse dyes on paper

Disperse dyes can be mixed with a gum called Indalca to create a dye paste that can be used to screenprint designs onto paper. These designs can then be heat-transferred onto any synthetic fabric. Indalca comes in powdered form, which must be mixed with water to make a gum; sprinkle the powder onto water and stir, then leave for a few hours until smooth. This is then mixed with a teaspoonsful of dye (already turned into a paste with a few drops of cold water) to create a printable mixture.

You need to prepare a photographic silkscreen or Thermofax with your design on it for this process. Once you have printed the design onto paper, you should allow the print to dry before heat-pressing it onto fabric.

Designs printed in this way can be heat-pressed at a later date, and should be stored away from sunlight.

Option 5: Florists' paper, wrapping paper or paper bags

Certain types of florists' paper, wrapping paper and patterned paper bags are impregnated with dye that can be used successfully in sublimation printing. Shapes can be cut out before being heat-pressed onto synthetic fabrics. Experiment with a range of papers to create varying results.

24 *Greenwich MY Greenwich,* **Lee Slack, 2009.** *Disperse print heat-transferred onto felt, 110 x 70 cm (43¼ x 27½ in.). Photo: Lee Slack.*

Option 6: Using a sublimation printer or an inkjet printer with sublimation inks

Using a sublimation printer can be an effective way of creating a complex or multicoloured image or design. This can be printed onto paper using disperse dyes and then heat-pressed onto any synthetic fabric. However, you must remember to flip the image horizontally before printing it onto paper, so that your design is transferred the right way up when the paper is placed face down on your fabric.

Similarly, sublimation prints can be produced with an inkjet printer using wax-based transfer paper (available from various internet suppliers) with standard inkjet ink cartridges. Alternatively, sublimation inkjet cartridges (also available from various internet suppliers) can be used with standard inkjet paper.

Option 7: Larger-scale digital printing onto paper

Instead of using a small sublimation printer, you can send or take your designs to a company or college to be digitally printed onto paper using disperse dyes. I have used various resources including Promptside, RA Smart and Goldsmiths College. The advantage of this way of producing a digital sublimation print is the ability to produce excellent-quality, large-scale designs that initially can be produced and manipulated on your computer (larger designs printed like this may need to be heat-pressed onto your fabric in sections, depending on the size or type of heat press available to you).

26 Roaming trolley light boxes, Dawn Dupree, 2008. *Digital sublimation print on double-layered Ripstop™ nylon, 345 x 107 x 40 cm (136 x 42 x 15¾ in.). Photo: Dawn Dupree.*

27 *Lycra™ sample layering sublimation paper, stencils and disperse-printed paper, by Dawn Dupree. Photo: FXP Photography.*

25 *Geisha Girls*, Dawn Dupree, 2003. *Digital sublimation print on Ripstop™ nylon, 2.5 x 1m (7½ x 3ft). Photo: FXP Photography.*

Notes and pitfalls

Shapes can be cut out of sublimation paper (bought, handmade or digitally produced) using paper scissors or a craft knife on a cutting mat. Alternatively, you can use stencil cutters (available from craft shops) to cut a range of shapes.

For best results when using the dye-sublimation process, manmade fibres should be used. Mixed-fibre fabrics (ideally with a minimum 60% synthetic content) can also be used, as can natural fibres, though both of these generally yield paler or more diluted colours.

Before heat-pressing, always place newsprint (or other paper) beneath the fabric and on top of any work or sample. This will absorb any dye and prevent back-staining from the Teflon™, which could become impregnated with dye that will transfer to any subsequent work or samples.

When pressing sublimation paper onto a photocopy, be careful not to heat-press for longer than about 60 seconds, as this could result in the paper sticking to the photocopy completely. Wait until it is cool before attempting to peel them apart, to minimize the risk of this happening. You can experiment with heat-press times during this process to vary the depth of shade achieved.

Do not dry dyed homemade sublimation papers in a baking machine, as it can distort dye colour when printed and is also a fire risk. If drying paper with a hairdryer, do not to leave it unattended.

Sublimation paper can be heat-pressed and re-used several times before the colour is exhausted. However, each subsequent pressing will result in a more diluted colour.

There are numerous ways to adjust the depth of shade produced during sublimation printing. As well as experimenting with times and temperatures used when heat-pressing, you can dilute the dye (by adding water) or add more dye to create a darker colour.

To make different colours you can mix different dyes together or press different sublimation papers on top of one another.

All the options discussed in this chapter can be overlaid and heat-pressed several times to create interesting multilayered prints.

28 *Sublimation samples made by students at Leweston School, Devon, during a workshop with Dawn Dupree, 2009. Photo: Dawn Dupree.*

Surfaces to transfer sublimation prints onto

Synthetic fabrics

Synthetic fabrics vary enormously. They can be bought in fabric shops, markets and wholesale suppliers. While sublimation printing was originally developed for polyester, this process can be used on a variety of man-made fabrics, and you can experiment with them to produce a range of different results. For instance, try using synthetic felt or fleeces. Alternatively, you could use synthetic yarns for your sublimation printing, either before or after further construction.

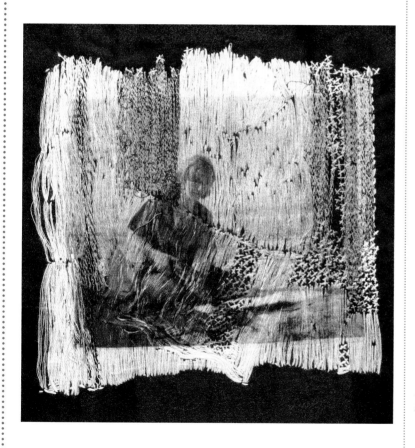

29 *Sarah*, Hannah Yate, 2008.
Polyester yarn and polyester sewing thread (hand-stitched and machine-stitched) printed with digital sublimation print onto silk, approx. 16 x 20 cm (6¼ x 8 in.). Photo: Hannah Yate.

30 *A selection of samples of synthetic fabrics and polymer-coated tiles. Photo: FXP Photography.*

Mixed-fibre fabrics, with some synthetic component (a minimum of 60% works best), can also be used to make sublimation prints. Various types of synthetic sports clothing – for instance, Lycra™ swimwear – as well as polyester umbrellas and numerous other ready-made items, make ideal substrates for receiving heat-pressed sublimation prints. Make sure you are able to flatten your garment or product in your heat-press, to avoid any distortion of the design.

Fabrics suitable for sublimation printing include: polyester, polyamide (nylon), Dicel, Tricel, acrylic, acetate, cellulose, viscose, vilene, synthetic velvets and mixed fibres.

Copper/aluminium tiles

Interesting results can be achieved by transferring your sublimation prints onto a copper or aluminium surface or tile. The colour of your transferred print will be altered once heat-pressed onto the shiny

surface. Copper colour adds a richness as it blends into the translucent colours of your sublimation print. These tiles can be bought or ordered from various sublimation suppliers and are available in various sizes. **You must cushion your tile on both sides with thick fabric, to protect your heat press and prevent any damage being done to your equipment.** Make sure you release the pressure wheel to accommodate the extra thickness of heat transferring onto tiles.

Acrylic or perspex tiles

Acrylic tiles can be used as a surface for sublimation printing. They can be ordered or bought from companies selling products for sublimation printing, or from other manufacturers. Heat-press your sublimation-paper design onto the surface of your tile to transfer it. Experiment with a range of different methods, times and temperatures.

31 *Polymer-coated tile samples, sublimation-printed with hand-painted transfer paints and digital images by Dawn Dupree and Fiona King. 10 x 10 cm (4 x 4 in.). Photo: FXP Photography.*

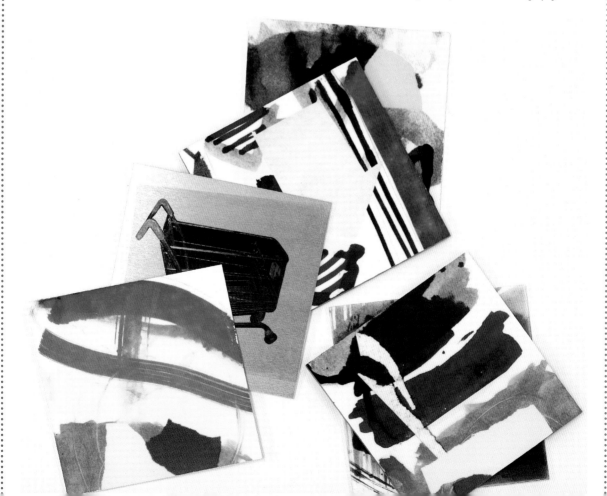

Polymer and polyester-coated surfaces

A number of products, samples or blanks can be bought to transfer sublimation prints onto. These are available from a range of companies online (see the list of suppliers at the end of the book).

Polymer-coated tiles (plastic, wood or aluminium) can be decorated using any of the sublimation processes discussed in this chapter. For best results, heat-press your paper/design onto your tile for 60 seconds at 200°C. For a sharper effect, try leaving the plastic film on your tile while heat-pressing. Alternatively, remove it for a softer result. In any event, you should only remove the film once it has cooled completely.

Suggestions will vary according to the type of heat press, as well as the time and temperature, you have used. Try using paper stencils as a mask to resist the transfer inks. The raised surface of the stencils can cause the heat-pressed colours to produce an interesting mottled effect. Greater depth can be achieved by layering colours and designs onto your tiled surface.

Suggested projects

Using a Lycra™ swimsuit or trunks as a blank canvas, paint brushstrokes onto plain paper with transfer dyes. Leave to dry, then place the paper face down onto the garment and heat-press for 1–2 minutes at 190°C (374°F).

Buy a simple kite to decorate, first removing any batons. Cut out shapes from sublimation paper and place face down on different sections to heat-press and transfer colour.

32 *Bonbon*, Catherine Shinerock, 2007. *Digital heat-press print. Photo: Catherine Shinerock.*

33 *Pillow leaf lapis*, Wendy Edmonds, 2006. *Heat-transfer print, shammy suedette feather insert, 31 x 31 cm (12¼ x 12¼ in.). Photo: Wendy Edmonds.*

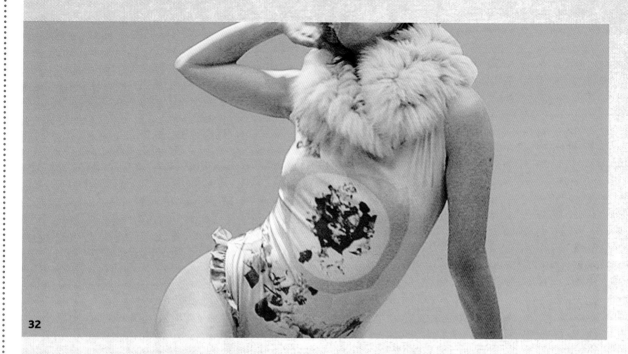

32

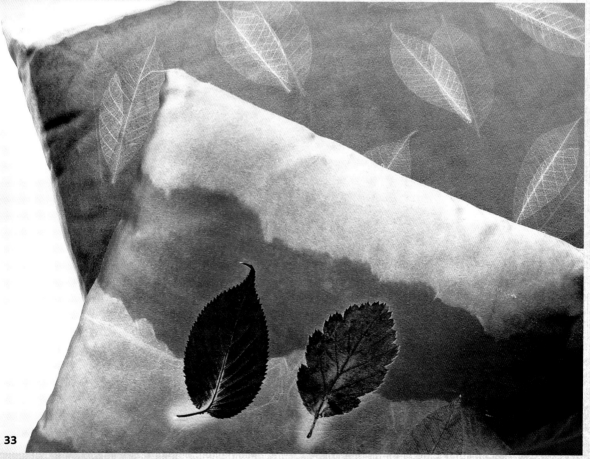

33

01

02

Fusing

10

Fusing involves sticking, joining, melting, blending and bonding of fabrics and/or other materials together in a heat press. This can be otherwise achieved using an iron.

In this chapter, I will explore several methods of fusing and the construction of composite textiles. I will also suggest some simple starting points and describe how you might progress further with your textile and mixed-media samples. As a result I hope you will be inspired to investigate the exciting, possibly limitless potential of fusing techniques.

There is enormous scope for experimentation with this process, during which double-sided and multilayered textiles can be produced with little effort. These non-woven fabrics could be subsequently used in a number of ways, including in fashion or accessories and in textile art. Various elements including fabric, paper, plastic, fibre and fusible web can be combined to create a range of unusual surfaces.

By experimenting with the layering and fragmenting of these ingredients (some of which contain adhesive properties, while others melt at certain temperatures), a number of unexpected outcomes can be achieved. However, results can often be unpredictable due to the nature of some of the materials used in the process. Plastics, packaging and meshes often become distorted out of recognition during the heat-pressing, whilst the look and feel of other fabrics and materials can be dramatically altered. Therefore times and temperatures used during heat-pressing may vary widely and can be adjusted according to test sample results.

01 *Restricted View*, Susan Eyre, 2008. *Cotton, polyester, organza, synthetic crushed velvet, digital print, disperse dye heat sublimation onto various synthetics. Individual images are fused to card using heat-reactive adhesive web. Complete installation 195 x 126 x 45 cm (76¾ x 49½ x 17¾ in.). Photo: Susan Eyre.*

02 *Conductive materials part 1* (sample), Berit Greinke, 2007. *Mirror foil, PVC tube and wire (20 seconds at 190°C/374°F), 10 x 15 cm (4 x 6 in.). Photo: Berit Greinke.*

There is no specific way to approach this technique, except with an open mind and a spirit of discovery. The best way is to experiment using different combinations of materials, times and temperatures until you begin to create interesting fabrics. There will certainly be some surprises along the way. You may find it helpful to the development of your ideas to keep a record of noteworthy experiments and samples, to help you judge how different materials might react.

Experimenting with composite textiles

There are many exciting ways to work with fusing, allowing for certain considerations. Your samples need to incorporate materials that melt when exposed to heat and pressure (for example, plastics, packaging or Tyvek™), or materials with an adhesive component that is activated when exposed to heat and pressure (e.g. adhesive webs), or a combination of the two.

Successful results can be achieved by trying and testing your materials with a range of times and temperatures.

Below is a list of materials suitable for this technique along with suggestions of fragments or objects that could be trapped within your composite fabrics. All materials are easily available either from listed suppliers, or from local hardware or fabric shops or office suppliers.

Before you begin to experiment, you must always make sure that all materials are sandwiched between two sheets of Teflon™ or baking paper prior to heat-pressing, to protect your equipment and prevent any plastics or adhesive webs melting onto the surface of your heat press or iron.

Materials with adhesive properties

Angelina fibres
Crystalina fibres
Bondaweb™
Spunfab™
Gossamer bonding mesh (FuseFX)
Other adhesive webs

03 *A selection of adhesive and fusible materials. Photo: FXP Photography.*

04 *A selection of coloured plastics, PVC fabrics, netting and packing tapes. Photo: FXP Photography.*

03

04

Materials with melting properties

Plastic bags (any colour, size
or type)
Plastic tablecloth
Packaging (foam or bubble wrap)
Polystyrene
Fruit and vegetable netting
Plastic office sleeves
Crisp packets, food packaging
PVC
Packing tape
Lutradur™
Evolon™
Tyvek™ paper
Tyvek™ fabric

Fragments/objects to trap

Fabric fragments
Sequins
Threads (any thickness)
Feathers
Leaves, skeleton leaves
Paper (photos/handmade/
magazine/tissue paper/tracing
paper/ stencils)
Hairnet
Surgical gloves
Doilies
Dried flowers, petals
Craft wire

Suggestions for other fabrics or materials that can be used in this process

Felt
Knitted fabric
Woven fabric
Plain/patterned/printed fabrics
Translucent fabrics
Netting

05 *Collages of PVC, plastic strips and
coloured tapes (samples) by Dawn Dupree
and Fiona King. Photo: FXP Photography.*

Fusing plastics

Ordinary plastic bags and packaging or materials that incorporate a plastic component (e.g. a plastic tablecloth) can be successfully melted together or fused onto another surface to interesting effect. By placing them in a heat press for a few seconds, layers of plastics can be fused together to create sturdy fabrics with further potential for more sculptural application.

06 *Sample made of fused plastics, film, fabric and paper, by Dawn Dupree. Photo: FXP Photography.*

A simple experiment

Firstly, lay down a sheet of Teflon™ (you can also use baking paper) on the base of your heat press. Choose a thick plastic bag to place on your Teflon™ sheet (you may need to cut it to fit, according to the size of your heat press). Cut shapes from a variety of other plastic bags in various colours and arrange these shapes on top of the first plastic bag. Completely cover your collage with another sheet of Teflon™ and heat-press for 2–10 seconds at 150°C (302°C). (You will need to experiment with melting times.) Remove from the heat press and take the Teflon™ sheets away to discover your fused plastic fabric.

More ideas and suggestions

You can fuse various plastics together in this way, while taking care not to over-press (i.e. not placing them in the heat press for too long) which may give results that are too melted or distorted for your liking. Plastics and materials with melting properties can also be fused together with a wide range of other, non-melting and non-adhesive materials. For example, try fusing plastic bags or packaging, etc. with a heavier fabric like felt or canvas, creating areas where original texture and/or colour has been distorted.

07 *Sample of raffle tickets, paper tags cotton threads and netting sandwiched between fabric, plastic and bonding mesh, by Dawn Dupree. Photo: FXP Photography.*

Alternatively, you can incorporate plastic materials into more complex and multilayered composite materials. Plastic materials often function as a way of connecting two non-adhesive materials together by melting onto both surfaces. Similarly, fragments and/or fibres can be trapped beneath the surface of a plastic material, sometimes creating a relief effect or texture.

Experiment with a range of materials that have a plastic component, fusing them together or combining them with other, non-melting materials. Refer to the list of materials with 'melting properties', or think of new ones to experiment with. Some of these materials (e.g. Lutradur™) need heat to be applied directly to distort them.

08 *Membranes 1* (samples), Zane Berzina, 2002. *Transfer printing, heat-setting, laminating and coating using technical polyester non-wovens, transfer dyes, silicone, paper and transfer film. 35 x 25 cm (13¾ x 10 in.).* Photo: Zane Berzina.

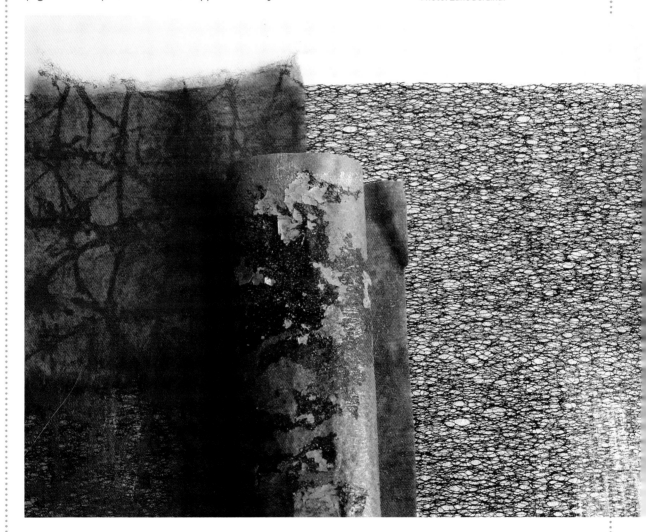

Fusing using adhesive filament webs

Adhesive webs can be used to bond two fabrics together with no alteration to their handling or appearance. These can be bought in various weights and sizes. The most common material used is Bondaweb™, but there are several other webs available including Spunfab™ and gossamer bonding mesh. All are activated by heat. One of the advantages of using these webs is that a strong bond is created, adding durability to your fused fabrics. Due to the lacelike quality of these webs, lightweight fabrics can be fused together, retaining an openness of structure without reducing flexibility.

A simple experiment

Firstly, place a sheet of Teflon™ onto your heat-press plate. Then choose a sample of any fabric as your base layer and place down on top of it a sheet of Bondaweb™ (once this has been removed from its plastic backing). Cut shapes from various fabrics and collage on top of the Bondaweb™. Finally, cover with another sheet of Teflon™ and place in the heat press for 10 seconds. When you remove the Teflon™ sheets your fabrics will be fused together. This process may also be done using an iron, in which case you need to use baking paper instead of Teflon™.

More ideas and suggestions

Adhesive webs can be used in a multitude of ways to create interesting and unusual results. Try experimenting with bonding contrasting weights of fabrics. Trap objects (e.g. sequins) and fragments of fabrics, sandwiching them between different fabrics. Webs can be cut into shapes for use in small areas and, rather than under, can also be laid over fabrics and materials, in the process often partially connecting surfaces.

Alternatively, gossamer bonding mesh (or another fusible web) can be placed between two layers of translucent or sheer fabric, before pressing, to create a patterned and visible web, or heat-pressed onto any surface (fabric) to embellish it. This type of fusible web can be coloured before being used in this way.

09 *A selection of translucent fabrics and skeleton foil fused using Bondaweb™ and other adhesive webs, by Dawn Dupree. Photo: FXP Photography.*

Bondaweb™ and other adhesive webs may be used to print negative flock or foil prints using the remaining flock or foil skeletons once peeled away after the original flock or foil print has been created. Whole sheets of flock or foil can be fused onto another surface using Bondaweb™ or other fusible web in place of flock or foil glue. These methods can be incorporated into your fused fabrics to create interesting, shiny or textured surfaces.

Fusing with heat bondable Angelina fibres/ Crystalina fusible fibres/fusible film

Heat-bondable Angelina fibres, also known as 'hot-fix', are made from very finely shredded fusible film. These polyester fibres can be bonded together, using a heat-press or an iron, to create a non-woven type of fabric. Lightweight web-like structures can be produced where layers of iridescent Angelina fibres are assembled together and sandwiched between Teflon™ or baking paper. This is then heat-pressed or ironed for a few seconds at approximately 50°C (122°F). During this process, the heat allows the fibres to soften and become fused. Unusual optical effects can be produced, and a range of surfaces achieved by collaging and fusing Angelina fibres with other fabrics and materials. More fibres can be added, and colours and textures become distorted as they are

fused again. These new composite fabrics and handmade sheets or webs of luminescent Angelina fibres can be subsequently developed in a number of ways.

Crystalina fusible fibres, which are 1.5mm wide saw-tooth-cut strips of fusible film used to make Angelina fibres, can also be used in the same way. Fusible film is the raw material for Angelina fibres and can be cut and fused together with Angelina fibres, Crystalina fibres and other materials.

A simple experiment

Place a sheet of baking paper or Teflon™ onto the base of your heat press. Tease out some Angelina fibres and arrange on top of the Teflon™ sheet or baking paper. Lay another colour of Angelina fibres over the first colour. Cover this completely with another sheet of baking paper or Teflon™. Heat-press for a few seconds at 50°C (122°F). Remove from the heat press to reveal your fibres fused together. This can also be achieved using an iron with fibres sandwiched between baking paper. Different times and temperatures yield a variety of different results, so it is worth experimenting with. You may also make a flat sheet of Angelina in this way by laying fibres neatly and evenly between two sheets of Teflon™ before pressing.

10 *Angelina fibres and Crystalina fusible fibres used to bond and mesh netting, plastics, paper and felt, by Dawn Dupree. Photo: FXP Photography.*

More ideas and suggestions

Hot-fix Angelina fibres can be blended with 'standard' or metallic fibres, which are not bonded at low temperatures. Colours may be mixed roughly or more thoroughly to produce varied results. You will need to experiment with different amounts of each type of fibre, and several times and temperatures, until they bond successfully during heat pressing or ironing. Play with allowing some colours to be exposed to heat pressing for longer than others and see how they are affected.

Another way to experiment using Angelina fibres is by incorporating flat objects or fragments. First you must lay some fibres onto a sheet of baking paper or Teflon™. Then add sequins, petals, threads, etc. (see list of objects to trap on p.90). Finally, lay more fibres on top and cover with Teflon™ sheet or baking paper. Heat-press or iron for a few seconds to fuse and bond all ingredients. The possibilities for working in this way are endless.

The 'standard' fibres will fuse together when exposed to higher temperatures, though this will affect the surface and reduce softness as a result.

Try several combinations of fibres, colours, methods, times and temperatures to create a range of samples. Lay down fibres in a variety of ways, taking into consideration that bonding occurs when fibres overlap. Discover how fine and delicately placed fibres can produce lacelike fabrics.

Alternatively, construct thicker fabric by fusing dense areas of fibres. Whilst the thickness is increased by adding more fibres, you may need to heat-press for longer or iron on both sides to bond effectively. Eventually, if your fibres need to be pressed for too long in order to bond, they will lose their vibrancy.

To make a flat sheet of fabric Angelina fibres must be laid neatly and evenly prior to heat pressing or ironing. Also, consider laying fibres in a loose pattern or even cutting them to different lengths before blending or fusing them together.

Skeleton fabrics can be created by placing layers of Angelina fibres between two layers of dissolvable fabric (available from Whaleys and other fabric suppliers), creating a sandwich. Pin along the edges of the sandwich and stitch across the surface to secure. This can be done in a random and haphazard fashion or with a more orderly pattern, by hand or using a sewing machine. Finally, dissolve in water (follow the manufacturer's instructions). If you have used cold water-soluble fabric (rather than hot), you will need to heat-press or iron the fabric between two sheets of baking paper to bond the Angelina fibres. Once the stitching and fibres have been fused together, you are left with an interesting composite fabric. Similarly, structure can be added to any lightweight fabric by laying Angelina fibres between a sheer fabric and a dissolvable one. This can be stitched into as before to secure, and dissolved and heat-pressed or ironed as before. This process can be varied by using different types of stitches in a range of densities.

Thermo-adhesive plastic films/inkjet transfer papers and foils

Thermo-adhesive plastic films are produced for commercial use to laminate fabrics. There are various types and qualities used industrially. Waterproof and transparent films with breathable properties are often used in sports clothing. For the purpose of experimenting, it is possible to substitute these films with inkjet transfer papers or foils. There are several types available which can be bought easily online (see the list of suppliers at the end of the book).

The disadvantage in using inkjet transfer papers is that whilst creating a water-resistant and durable surface, the coated fabric is no longer breathable. It also makes for a stiffer surface on most fabrics. However, interesting surfaces and composite fabrics can be produced using inkjet films (also known as photo-transfer papers) in various colours, textures and weights, as they can be applied to any fabric.

You could experiment further by collaging flat objects, threads and fragments with these films, fusing them together during heat pressing to create samples with interesting surfaces.

11 *Membranes 1* (exhibition view), **Zane Berzina, 2003.** *Mixed media, transfer printing, bonding, layering and screenprinting using various technical polyester non-wovens, silk, latex, silicone; 10 textile panels, each 60 by 250 cm (23½ x 98½ in.). Photo: Zane Berzina.*

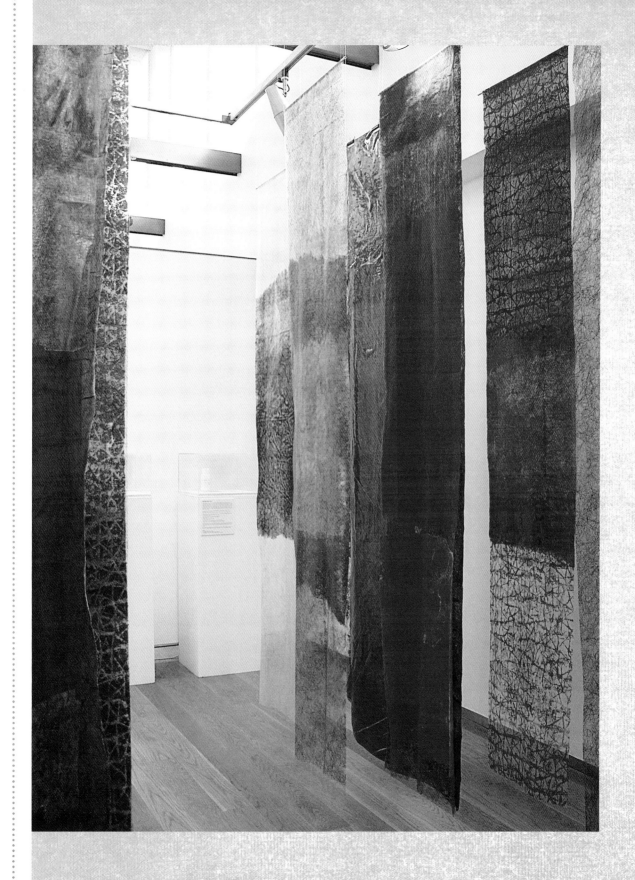

Colouring fusible fabrics and materials

Many of the materials I have suggested to use in the fusing process are made from polyester or other manmade substances. These synthetic materials can be coloured using dye-sublimation methods and materials. However, it is not possible to heat-press certain fusible materials using dye-sublimation papers at the high temperatures needed to yield strong colour results without potentially destroying their bonding ability or the materials shrinking completely. Therefore, it is advisable in most cases to use disperse dyes (mixed with water), transfer inks, transfer crayons, and other transfer dye products applied directly to the surface of the materials (e.g. by painting or drawing) prior to heat-pressing or ironing. You will need to experiment with these materials to find out what works well.

Materials applied directly to polyester and other synthetic materials

Disperse dyes (mixed with water)
Colourist transfer inks
Deka™ Iron-On
Berol™ transfer paints
Jacquard Dye-Na-Flow
Crayola™ transfer crayons

Additionally, if attempting to colour sheets of Angelina fibres by heat-pressing them together with sublimation papers, you must ensure that the temperature you use to transfer colour is not so hot that the fibres are distorted and become dull as a result.

Below I have identified some of the main materials used in this chapter that can be coloured or patterned with sublimation methods. I have explained their different properties and suggest how they can be coloured before, during or after the fusing process. This can be achieved in various ways including direct painting, stencilling or printing.

Fusible web (also known as gossamer bonding mesh or FuseFX)

You can use any transfer dyes, inks or paints to paint directly onto the surface of any fusible web, then allow to dry. The colour will be subsequently fixed during the ironing or heat-pressing process. You may also colour fusible webs using fabric paints or acrylics.

Lutradur™

Lutradur™ is a non-woven, spun polyester. This can be coloured using any dye-sublimation technique as its robust nature will allow it to be heat-pressed or ironed at high temperatures for several minutes to transfer colour or pattern. You may also use fabric paints, acrylics, paint sticks and other products or materials to decorate Lutradur™.

Evolon™

Evolon™ is a new microfilament fabric consisting of a polymer mix that has the appearance and feel of a traditional fabric. Evolon™ can be successfully coloured either by dyeing (including the use of acid dyes) or by any method of sublimation printing.

Tyvek™

Tyvek™ is the Dupont™ brand name for spunbonded olefin (a strong-yarn linear polythene). It is durable, waterproof and unrippable, and is produced in various formats (e.g. disposable decorating suits are made of Tyvek™). It will shrink at 104°C (219°F) and melt at 135°C (275°F). Fibre film or Fibertex™, both available in different weights, are also made of Tyvek™. Tyvek™ can be coloured using disperse dyes, transfer inks and other sublimation products. Experiment by applying materials on both sides of the fibre film or Fibertex™ with a brush, sponge or spray. Fabric paints, silk paints, inks, coloured pencils, felt pens and spray paints can also be used to apply colour.

Fibre film (only) can be fed through the photocopier or printer to apply a printed design or outline prior to colouring.

Angelina

Angelina fibres are made from polyester that can be coloured using dye sublimation. This is most successful when transferring the darkest colours (e.g. transfer ink or disperse dye) onto lighter fibres. Several other products can also be used to decorate Angelina surfaces including acrylics, paint sticks and fabric paints.

All other fabrics and materials used during the fusing processes can be decorated or coloured before or after heat pressing. This may be done using a range of textile products suitable for each specific material. For example, you could print using pigments onto felt, or hand-paint using Procion dyes on linen.

There are several other ways to embellish fusible fabrics and materials. Areas of flock or foil can be added by painting or printing with flock or foil adhesive onto the surface of any fusible fabric (e.g. on a sheet of Angelina). This must be dried prior to heat-pressing or ironing, with a sheet of flock (face down) or foil (colour up) covering your design. PVA may also be used instead of foil glue.

Alternatively, try ironing foils directly onto the surface of fused Angelina fibres to decorate sections. Always cover your work with baking paper before applying heat.

Stitching is another method of embellishment which can pattern, colour and distort various materials used in fusing fabrics. Sewing directly onto the surface of materials that shrink once exposed to heat can create fascinating and unpredictable results. This idea can be developed further by sewing contrasting materials together in sheets, sections or combinations of both. Experiment with a range of stitches and materials to discover the potential of fusible fabrics patterned in this way. Whilst you need to be aware of suggested times and temperatures for ironing and heat-pressing various products, sometimes unexpected reactions are revealed when these are slightly altered during the bonding process.

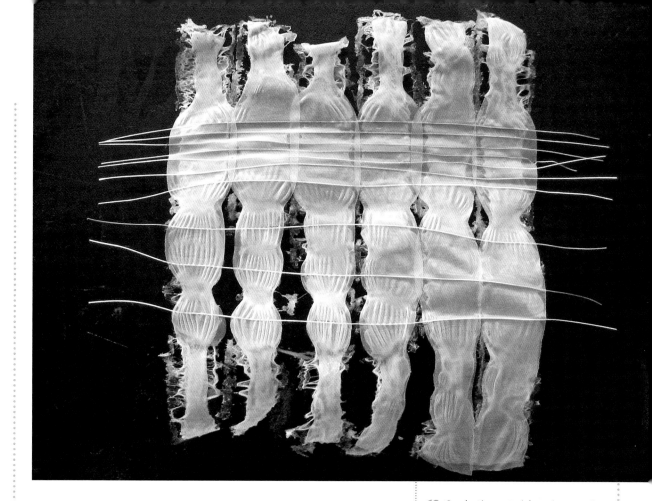

More complex experiments and ideas for further investigation

Many of the processes and materials in this chapter can be blended together by layering, cutting, collaging and fusing once again. Plastics, fusible webs, Angelina fibres, films and other products and materials can be bonded or fused in endless combinations. Try layering collected fragments, fibres and samples to create exciting new composite fabrics. Specialist fusible fabrics (e.g. Easy Fuse Ultrasoft or 'fusible nylon white') are available from Whaleys and other fabric shops.

Most of the ideas discussed in this book involve two-dimensional surfaces, but some of the materials used in this chapter can be manipulated to achieve more three-dimensional, sculptural results. There are several ways to approach this. For example, incorporating wires into the layers of a composite fabric prior to heat-pressing or ironing allows for construction afterwards.

12 *Conductive materials project part 1 (sample), Berit Greinke, 2007. Adhesive tape and wire, c.5 seconds at 190°C, 15 x 15 cm (6 x 6 in.). Photo: Berit Greinke.*

▶ **NOTE**
Though most fusing
experiments can be achieved
using a heat press or
domestic iron, you can also
apply other sources of heat
to melt, distort or fuse some
of the materials. This could
include a small candle, a hot-
air tool or an oven. Please
refer to relevant materials
for specific instructions. Do
not attempt to investigate
these methods without
further research and without
taking appropriate safety
precautions; some materials
require that you wear a mask
when applying direct heat.

13 Knitted, stitched, heatpressed and
lazercut composite (detail), Tracy Hunt,
2007. *Polyethelene, polypropylene,
viscose, organsin, 33 cm (13 in.) high and
88 cm (34½ in.) in diameter. Research
conducted at The London Metropolitan
University for the On The Fringe exhibition
hosted at the university in conjunction
with the ETN conference based on digital
craft. Photo: Tracy Hunt.*

Stitching into the surface of a fusible fabric, before exposure to
heat, creates distorted shapes once heat is applied. Some fabrics and
packaging shrink excessively and can become brittle when overheated,
often leading to interesting sculptural forms.

Numerous other methods can be utilized including folding, cutting,
piercing, weaving and pleating. Try experimenting further with these
suggestions, either before or after you have fused your selected
materials. Once you have made various samples, you could experiment
further with colouring, patterning, embellishing and structuring these
new fabrics.

Notes/pitfalls

Make sure you use Teflon™ or baking paper under your work, as well as
to cover it, before pressing. Be careful not to heat-press certain plastics
and webs for too long, as they can shrink very quickly. Do not press too
hard or for too long when using Angelina fibres as they can lose their
iridescence. After heat-pressing with fusible materials, it is advisable to
wait until they are cool before peeling away baking paper or Teflon™,
so as to prevent fragmentation.

Health and safety

Make sure any colouring materials used with fusing materials or fabrics
are able to withstand heat and will not give off toxic fumes (see
individual product safety information).

Fibre film (Tyvek™) and other fusible materials often retain heat, so to
avoid burning yourself be careful when removing them from baking paper.

Suggested projects

Try fusing layers of translucent materials (e.g. Ripstop™ nylon, plastic,
webs and netting) together to create a semi-opaque fabric that could
be stretched over a lampshade frame. Fragments could be trapped
between layers to create an X-ray-like aesthetic.

14 *Sample made with surgical glove, fabric fragments, Angelina fibres and Crystalina fusible film, trapped and fused between translucent fabrics, by Dawn Dupree. Photo: FXP Photography.*

01 *Membranes 1* (samples),
Zane Berzina, 2002. *Transfer printing,
heat-setting, laminating and coating
using technical polyester non-wovens,
transfer dyes, silicone, paper and
transfer film, 35 x 25 cm (13¾ x 9¾ in.).
Photo: Zane Berzina.*

Heat-setting and Embossing

11

Thermal setting is a means by which manmade fabrics can be permanently creased or embossed. Nylon tights are thermo-fixed to hold their shape, and pleated garments are similarly heat-set to retain the pleats after washing. By heat-pressing synthetic fabrics at a temperature that is a fraction below their melting point, their surface can be manipulated and fixed (or 'set') into a different form. The most successful results can be achieved using polyester, polyamide and polypropylene fabrics. Tests must be carried out to determine the temperature at which different fabrics melt, as this can vary enormously. This can be done by placing a small sample of folded fabric between two sheets of Teflon™ or baking paper and heat-pressing for a few seconds. Keep pressing your fabric, whilst increasing the time gradually, until the fabric starts to set or permanently crease.

02 *A selection of heat-setting materials: pinned nylon, pleated polyester and creased polypropylene. Photo: FXP Photography.*

There are a number of ways of using these techniques and developing your ideas for heat-set fabrics. Below I have outlined several methods, which can be used separately or together. Experiment with different times and temperatures to produce a range of interesting samples.

Pleating

Fabric can be pinned or lightly ironed into pleats before being heat-pressed. This method could be adapted by varying the size or direction of your pleats, or pleating first one way then another. Wait until the fabric has cooled before unpinning.

Folding

Try folding your fabric and holding it in place with paperclips or pins, to create three-dimensional shapes. Then heat-press and remove the paperclips once cooled.

Creasing

By randomly squashing your fabric together and heat-pressing it without laying it flat, colour can be introduced (using dye sublimation papers) to create interesting effects in the creased fabric.

03 *Traces* (detail), Caroline Bartlett, **2009.** *Heat-set and crushed polyester with cotton thread, 32 x 92 cm (12½ x 36¼ in.). Photo: Caroline Bartlett.*

04 *Hand-stitched and heat-set polyester taffeta sample coloured with dye sublimation, by Dawn Dupree. Photo: FXP Photography.*

Stitching

Hand-stitch loose marks into your fabric and pull the threads to gather or machine-stitch patterns to ruffle your fabrics. Unpredictable shapes will occur once heat-pressed. Both hand-stitching and pulling threads could be extended to include different types of stitches, threads and tensions. Try smocking for a more ordered heat-set fabric. Once you have heat-pressed your stitched fabric, you can either remove the threads or leave them in.

Tying

Fabrics can be tied with string, elastic bands or wire in an ordered or haphazard way, to construct and distort prior to heat-setting. As with other methods, your fabric can be untied after being heat-set.

Baking paper and aluminium foil

Relief patterns can be created by folding fabrics together with aluminium foil or baking paper. Alternatively, try making marks in foil and heat-pressing for an embossed design.

All these processes can be combined with dye-sublimation techniques to create more complex samples and develop your ideas further. Most synthetic fabrics can be coloured or patterned in this way, before, during or after the setting or embossing process. The potential for experimentation and subsequent application of these techniques is limitless.

05 *Fleece palm verdant scarf* (detail), **Wendy Edmonds 2006.** *Heat-transfer-printed pleated spun-poly fleece, 180 x 25 cm (71 x 10 in.). Photo: Wendy Edmonds.*

Fabrics suitable for heat-setting

Fabrics that can withstand a long time in the heat press and have a high-temperature melting point are well-suited to heat-setting techniques. They can also be used to produce a range of distorted sculptural surfaces or be combined with fusing techniques or sublimation processes.

All types of polyester are suitable, including:
Polyester chiffon
Polyester taffeta
Polyester voile
Polyester Crystal Organza

Curtain netting
Cheap screen mesh
Satin polyester
Cotton Lycra™ polyester

Polyamide (or nylon) including:
Paper nylon
Ripstop™ nylon
Nylon organza arabelle

Fabrics with a low-temperature melting point could also be combined with dye sublimation techniques. These include:

Polypropylene (or disposable decorating overalls)
Tyvek™

06 A selection of materials for heat-setting. Photo: FXP Photography.

Suggested materials for heat-setting and embossing processes

Cotton or polyester thread
Embroidery threads
String
Wire (various weights)
Needles
Screws
Flat metal shapes (e.g. washers/
mirror plates/discs/coins/keys)

Buttons
Beads
Safety pins
Pipe cleaners
Paperclips
Dressmaking pins (various sizes)
Rubber bands
Aluminium foil
Baking paper
Wooden shapes
(these could be laser-cut)
Cardboard
Starch

07 *Sample of machine-stitched and dye-sublimation-printed polyester chiffon, by Dawn Dupree. Photo: FXP Photography.*

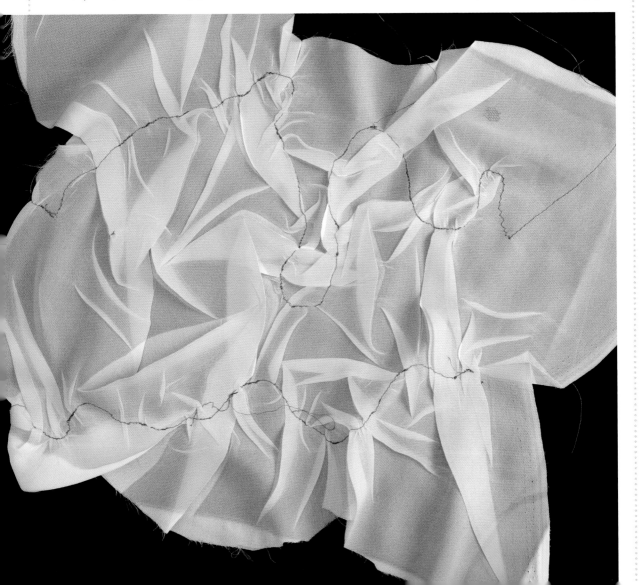

08 *A selection of fabrics and objects used for embossing. Photo: FXP Photography.*

A simple experiment with heat-setting

Choose a piece of white or pale-coloured synthetic fabric. Note that for this experiment you should use fabric with a high melting point, e.g. polyester taffeta. Stitch your fabric with coloured thread. Pull the threads tight to create an uneven surface to your fabric. Place your fabric on a sheet of paper on the base of your heat press. Lay a sheet of sublimation paper (bought or handmade) face down over your stitched fabric and completely cover with a plain sheet of paper or newsprint. Heat-press for between 10 seconds and 2 minutes at 180–200°C (356–392°F), the duration depends on the shade required and the fabric used. Remove from the press and notice how the fabric retains its original colour where creases have been permanently pressed.

Fabrics combining heat-setting and sublimation techniques could be further constructed into delicate and flowing garments that reveal colour as they move. Alternatively, using Bondaweb™ they could be fused to another surface prior to construction. The translucent property of many of the fabrics used in this process allows for interesting adaptation, e.g. lighting, window covering or screens and textile installation.

Embossing

Unlike with heat-setting, where the process is mainly limited to manmade fabrics, a different range of fabric types can be used for embossing. Experimentation is essential and can often produce inspiring surfaces and beautiful relief patterns. Fabrics with texture, thickness and pliability work well, e.g. neoprene or felt.

09 *A selection of embossed samples, by Dawn Dupree: Resida bump cotton fused with white foil, neoprene, industrial felt and synthetic felt.*
Photo: FXP Photography.

A simple experiment with embossing

Cover your heat-press base with a thick fabric, e.g. blanket, and place a sample of white synthetic felt onto the blanket. On this lay an assortment of objects (e.g. beads, lengths of string, screws), cover with another piece of thick fabric to protect your plate, and heat-press for 1–2 minutes at 180–200°C (depending on the depth of embossing required). To further enhance the embossing in this experiment, try placing a piece of sublimation paper face down over the objects prior to heat-pressing. Cover any sublimation paper with a sheet of paper or newsprint, then thick fabric, and finally heat-press for 1–2 minutes, depending on the depth of shade required. Experiment with times and temperatures for different results.

Other embellishment methods (e.g. flock, foil, photo transfer, fusing, print and stitch) can be incorporated into your fabric samples and employed at any stage of the process. For example, a piece of polyester fabric printed with a foil design when flat could be subsequently pinned and heat-set into pleats. Try different combinations of colouring and patterning of your fabrics before heat-setting or embossing them. You could also consider combining any of these surface decoration techniques during or after the heat-setting or embossing process. For example, try foiling the surface of an embossed fabric.

Fabrics suitable for embossing

Neoprene
Felt
Blanket
Wool
Leather
Velvet
Resida bump cotton

10 *Peacock Rose*, Bailey Tomlin, **2009.** *Satin petals, crin, wire and crystal stamens; hand-coloured and embossed petals, 15 x 15 cm (6 x 6 in.). Photo: Andra Nelki.*

Notes/pitfalls

Always make sure you protect your heat-press base and metal plate when using metal objects for embossing. This is best achieved by laying down thick fabric (e.g. blanket or felt) both on top and underneath any fabric, samples or objects during this process. You may need to replace this blanket or felt as it becomes indented, which is something you'll need to check before each pressing.

To avoid burns, wait until your embossing objects have cooled before removing them from your fabric samples, especially metal pins and other objects as they retain heat for considerable time after heat-pressing.

Be careful not to insert objects that may damage your heat press whilst embossing. If you are using flat metal objects (e.g. keys) and finding it difficult to close your heat press, it is advisable to release the tension (usually by adjusting a tension wheel located on the top of the press), which will allow you to press your fabric more easily.

Do not forget when using sublimation papers you need to sandwich your work between two layers of newsprint (or other paper) before heat-pressing. This will avoid any back-staining on your heat-press plate and will also to keep your Teflon™ sheet clean.

When testing your fabrics for melting times before heat-setting, make sure you sandwich your fabric between two sheets of Teflon™ or baking paper. If your fabric does melt, it can be peeled off once cooled.

More embossing ideas/further experiments

Embossing with Angelina

Another way to use the embossing process is to make samples or sheets of Angelina with Angelina fibres and lay them over a wooden block (e.g. a wooden printing block). By using an iron you can mould the sheet of Angelina sample across the block, moving the iron backwards and forwards until the Angelina has been embossed with the wooden block pattern. You will need to experiment with times and temperatures to create an effective relief pattern.

11 *Knitted, heat-pressed and moulded wall tile (detail of sample), 2007. Polyethelene and viscose. Research conducted at The London Metropolitan University for On The Fringe, an exhibition hosted at the university in conjunction with the ETN conference based on Digital/Craft. Photo: Tracy Hunt.*

Embossing with card/foil

Try folding card or foil several times in an ordered or random pattern, with many overlaps. Use it to emboss your fabric, creating an origami-like pattern.

Embossing with paper

Paper can also be embossed. Thick, textured or homemade papers work well. You could even dampen them before heat-pressing. Take extra care not to press for longer than 10 seconds, to avoid any fire risk.

Further investigation

Many of the fabrics used in the heat-setting process can also be manipulated and distorted by a number of alternative methods including baking, boiling, and heat-gun application.

Project suggestions

Try combining dye sublimation with thermal-setting to create a sculptural scarf or garment. A small sample of embossed fabric could be sandwiched between glass to create a unique contemporary wall panel.

12 *Neoprene sample embossed with keys, by Dawn Dupree. Photo: FXP Photography.*

Suppliers

UK

ADKINS

Adkins & Sons Ltd
High Cross
18 Lancaster Road
Hinckley
Leicestershire
LE10 0AW
Tel: +44 (0)1455 891291
www.adkins.com
Established manufacturers of heat-transfer and fusing machines.

ARIO

Ario 5
Pengry Road
Loughor
Swansea
SA4 6PH
Tel: +44 (0)1792 529092
www.ario.co.uk
Sells Tyvek™, dyes, transfer inkjet paper, foils and other craft supplies.

ARTVANGO

The Studios
1 Stevenage Road
Knebworth
Hertfordshire
SG3 6AN
Tel: +44 (0)1438 814946
www.artvango.co.uk
Extensive suppliers of various products including FuseFX bonding mesh, Fibre DK non-woven spun polyester fabric, and Deka™ and Berol™ transfer paints. Angelina fibres also sold.

COLOURIST

Colourist Fabric Transfer Paints
Denford Manor Barn
Bath Road
Hungerford
Berkshire
RG17 0UN
Tel: +44 (0)1488 686866
www.colourist.co.uk
Sells a beautiful range of fabric transfer paints.

CRAFTY COMPUTER PAPER

PO Box 9371
Syston
Leicestershire
LE7 1XH
Tel: +44 (0)1162 690960
www.craftycomputerpaper.co.uk
Sells digital papers for inkjet or laser printers. Also stocks foils.

FIBRECRAFTS

George Well & Sons Ltd
Old Portsmouth Road
Peasmarsh
Guildford
Surrey
GU3 1LZ
Tel: +44 (0)1483 565800
www.fibrecrafts.com
Stocks transfer inks, Angelina fibres, photo-transfer paper and disperse dyes alongside various other supplies.

FUJIFILM SERICOL UK Ltd
Pysons Road
Broadstairs
Kent
CT1Q 2LE
Tel: +44 (0)1843 866668
www.sericol.co.uk
Has a selection of foil, flock and sublimation transfers.
Also sells adhesives, transfer papers and blanks.
Supplies Seritrace draughting film.

HANDPRINTED.CO.UK
www.handprinted.co.uk
Drawing fluids, screenprinting supplies
and transfer dyes.

HIVA PRODUCTS
Disraeli Street
Aylestone
Leicester
LE2 8LX
Tel: 0116 283 6977
www.hiva.co.uk
Sells flock paper by the roll and offers various other
services and products.

HOME CRAFTS DIRECT
PO Box 38
Leicester
LE1 9BU
Tel: +44 (0)116 2697733
www.homecrafts.co.uk
Screenprinting stencils and filler, screens, squeegees,
screen-coating troughs, and screen mesh.

IMAGE FABRICATION
14 Mulberry Court
Bourne Road
Crayford
Kent
DA1 4BF
Tel: +44 (0)1322 554455
www.imagefabrication.co.uk
Large-scale photo-quality digital prints on fabric and
paper (for sublimation printing).

JOHN PURCELL PAPER
15 Rumsey Road
London
SW9 OTR
Tel: +44 (0)20 7737 5199
www.johnpurcell.net
Sells newsprint paper and True-Grain polyester
drawing film.

KEMTEX EDUCATIONAL SUPPLIES
Chorley Business and Technology Centre
Euxton Lane
Chorley
Lancashire
PR7 6TE
Tel: +44 (0)1257 230220
www.kemtex.co.uk
Suppliers of dyes, dye kits, dust masks, surgical
gloves, auxiliary chemicals, Manutex™, process
information and safety data.

LEONHARD KURZ (UK) LTD
Garnet Close
Greycaine Industrial Estate
Watford
Herts WD24 7JW
Tel: 01923 249 988
www.kurz.co.uk
Sells foils.

LAZERTRAN
Tel: +44 (0)1545 571187
www.lazertran.com
Transfer paper and other Lazertran products.

LONDON GRAPHICS CENTRE
www.londongraphics.co.uk
*System 3 screen-drawing fluid and screen block,
Speedball™ drawing fluid, screen filler and photo-
emulsion. Silkscreens and squeegees.*

LONDON SCREEN SERVICE
Unit A403, Tower Bridge Business Complex
100 Clements Road
London
SE16 4DG
Tel: +44 (0)20 7232 0363
www.londonscreenservice.co.uk
*Silkscreens (new and re-stretched), screen mesh,
photo-emulsion, coating troughs, squeegees, screen
dissolve. Screenprinting workshop for hire. Heat press
avaliable.*

THE MAGIC TOUCH
Unit 4
Apex Business Centre
Boscombe Road
Dunstable
Bedfordshire
LU5 4SB
Tel: +44 (0)1582 671444
www.themagictouch.co.uk
*Suppliers of sublimation products and equipment
including heat presses.*

PENNY MARRIOTT
penmario@googlemail.com
*Sells large sheets of sublimation paper.
Great colours.*

QUALITY COLOURS
Unit 13, Gemini Business Estate
Landmann Way
London
SE14 5RL
Tel: +44 (0)20 7394 8775
www.qualitycolours.com
*Pigments, dyes, Manutex™ and other
screenprinting supplies.*

RA SMART
Clough Bank
Grimshaw Lane
Bollington
Macclesfield
Cheshire
SK10 5N2
Tel: +44 (0)1625 576232
www.rasmart.co.uk
*Sells an extensive range of screenprinting supplies
including squeegees, flock paper, foils, and flock and
foil adhesives. Also stocks heat presses and blanks.
Produces digital prints on paper for dye sublimation.*

SIMPLY SEQUINS
6 Fairfield Terrace
Havant
Hants
PO9 1BA
Tel: +44 (0)2392 476125
www.simplysequins.co.uk
*Sells heat-bondable Angelina, Crystalina and fusible
film. Also stocks fibres, various sequins and threads.*

THERMOFAX SCREENS
Foxley Farm
Foxley
Towcester
Northants
NN12 8HP
www.thermofaxscreens.co.uk
*Made-to-order and ready-made Thermofax screens,
lightweight squeegees and pigments.*

WHALEYS (BRADFORD) LTD

Harris Court
Bradford
BD7 4EQ
Tel: +44 (0)1274 576718
www.whaleys-bradford.ltd.uk
A wide selection of fabrics including synthetics, mixed fibres and fusible fabrics.

XPRES

Oakridge Park
Trent Lane
Castle Donington
Derby
DE74 2PY
Tel: +44 (0)1332 855050
www.xpres.co.uk
Sells heat presses and sublimation products.

USA

ALJO® MFG. CO.

49 Walker Street, first floor
New York City
NY 10013
Tel: +1 212 226 2878
www.aljodye.com
Synthetic dyes and other supplies.

DHARMA TRADING CO.

1604 Fourth St. San Rafael, CA 94901
Tel: +1 800 542 5227
www.dharmatrading.com
A selection of transfer papers.

FUJIFILM SERICOL

1101 W. Cambridge Drive
Kansas City
KS 66103
Tel: +1 913 342 4060
www.fujifilmsericol.com

Has a selection of foil, flock and sublimation transfers, as well as other printing supplies.

Australia

FUJIFILM AUSTRALIA PTY LTD

114 Old Pittwater Road
PO Box 57
Brookvale
NSW 2100
Tel: +61 2 9466 2600
www.sericol.com.au
Has a selection of foil, flock and sublimation transfers, as well as other printing supplies.

KRAFTKOLOUR P/L

PO Box 379
Whittlesea
Vic 3757
Tel: +61 1300 720 493
kraftkolour.com.au
Sells dyes, inks and auxilaries.

Courses and Facilities

Heat-press workshops and textile print workshops in the UK

1. Dawn Dupree. I have extended experience and will lead workshops in both educational and community settings (of all ages and abilities). dawn@dawndupree.com

2. London Printworks Trust has a large-scale heat press which can be used as part of textile print studio hire. A 5-day introduction to printed textiles course or a specialist heat transfer course is available with tutor Dawn Dupree. www.londonprintworkstrust.com Tel: 020 7738 7841

3. Imogen Evans MDES (RCA). 'Fabric Design for Fashion Using a Heat Press' is a one-week course at Central Saint Martins College, University of the Arts London, creating samples for fashion and furnishing fabrics. www.csm.arts.ac.uk/shortcourses Tel: 0207 514 7022

4. 'Heat Transfer for Textiles' course at University of the Arts London, Chelsea www.chelsea.arts.ac.uk Tel: 020 7514 7751

5. Morley College in London runs a textile foundation course incorporating heat-press processes. www.morleycollege.ac.uk Tel: 0207 928 8501

6. City Lit adult education centre in Central London runs textile courses, some of which incorporate heat press techniques. www.citylit.ac.uk Tel: 0207 492 2586

7. Carole Waller runs a course called Fabric Transformations: 'Heat Transfer Printing' at West Dean College, West Sussex. www.westdean.ac.uk Tel: 01243 811301

8. London Screen Services hires out print workshop space and incorporates a heat press. www.londonscreenservice.co.uk Tel: 020 7232 0363

9. Goldsmiths College in London has a large-scale and rotary heat press in their textile print room, which is available for hire. www.gold.ac.uk Tel: 020 7919 7683

NB For larger-scale work, there are several colleges that will hire the use of their heat press even if you are not enrolled on one of their courses.

Further Reading

Beal, Margaret, *Fusing Fabrics* (London: Batsford, 2005).

Beaney, Jan and Littlejohn, Jean, *Transfer to Transform Book 4* (Slaithwaite, West Yorkshire: Double Trouble Enterprises, 1999).

Benn, Claire and Morgan, Leslie, *Breakdown Printing* (Surrey: Committed to Cloth, c.2005).

Braddock, Sarah E. and O'Mahony, Marie, *Techno Textiles 1 and 2* (London: Thames and Hudson, c.1998 [1]; 2005 [2]).

Colchester, Chloe, *Textiles Today* (London: Thames and Hudson, 2007).

Dunnewold, Jane, *Improvisational Screen Printing* (San Antonio, Texas: Artcloth Studios, publication date unknown).

Fish, June, *Designing and Printing Textiles* (Ramsbury, Wiltshire: The Crowood Press, 2005).

Kinnersly-Taylor, Joanna, *Dyeing and Screen-Printing on Textiles* (London: A&C Black, 2003).

Midgelow-Marsden, Alysn, in conjunction with Art Van Go, *Between the Sheets with Angelina: a workbook for fusible fibres* (Evesham, Worcestershire: Word4word, c.2003).

Wells, Kate, *Fabric Dyeing and Printing* (London: Conran Octopus Limited, 1997).

Resources/research/magazines

62 group: A group of textile artists which provides opportunities for professional textile artists to exhibit and promote their work. www.62group.org.uk

Crafts Council: The national development agency for contemporary crafts in the UK, it also produces *Crafts Magazine*, featuring articles and information about contemporary craft. www.craftscouncil.org.uk

Embroidery magazine: A bi-monthly magazine produced by Embroiderers' Guild about embroidery and makers, incorporating interesting articles, information and suppliers. www.embroiderersguild.com

ETN: The European Textile Network is a networking organisation for textile artists and institutions. www.etn-net.org

Selvedge magazine: A beautifully produced quarterly magazine showcasing contemporary and historical textiles in a broad context, including interiors, fashion, art and travel. www.selvedge.co.uk

TED: The Textile Environment Design resource located at Chelsea College of Art draws together samples, products, imagery and information about eco-textiles and fashion. www.tedresearch.net

Glossary

adhesive web Fine, web-like material used to stick two textile surfaces together with the application of heat.

disperse dye Dyes used for colouring synthetic fabrics.

embossing Technique for achieving permanent indentation by pressing hard objects onto a softer surface.

fusible fabrics Fabrics that melt and stick to another surface when heat is applied.

layering Overlaid images, designs or materials (often blending certain aspects).

newsprint Newspaper before it's printed, used to make paper stencils for screen printing.

opaque Material that blocks out light or background.

photogram Negative image created by using object or stencil to mask fabric.

photographic stencil A black and white image on tracing paper or acetate.

process black Thick paste used to create an opaque design on a translucent surface.

resist A substance or material used to prevent dye or pigment being applied to certain areas of fabric.

smocking Stitching technique where loose ends can be pulled to produce ruffled fabric.

sublimation technique A process used to transfer disperse dye or transfer inks from paper to synthetic fabric through the application of heat.

substrate The fabric or surface to which dyes and chemicals can be applied.

transfer inks/paints/paper Products used in sublimation printing for colouring synthetic fabrics.

translucent A semi-transparent material that allows light through.

upcycle Adding value through design, for example reconstructing or printing onto second hand clothes.

Index

More **TEXTILE** HANDBOOKS

TEXTILES HANDBOOK

mixed media & found materials

Lucy Renshaw

ISBN: 9781408101032

TEXTILES HANDBOOK

flower pounding

Linda Rudkin

ISBN: 9781408127469

TEXTILE HANDBOOK

natural dyes

Linda Rudkin

ISBN: 9780713679557

TEXTILES HANDBOOK

creative machine embroidery

Linda Miller

ISBN: 9781408103982

TEXTILES HANDBOOK

felt

Sabine Fouchier

ISBN: 9780713684940

TEXTILES HANDBOOK

framing and presenting
textile art

Annabelle Ruston

ISBN: 9780713688085

TEXTILE HANDBOOK

textile surface decoration:
silk and velvet

Margo Singer

ISBN: 9780713669534

TEXTILE HANDBOOK

the yarn book

Penny Walsh

ISBN: 9780713669558

£15.99 each • Paperback

www.acblack.com

A&C
B